DRAWING
MANGA

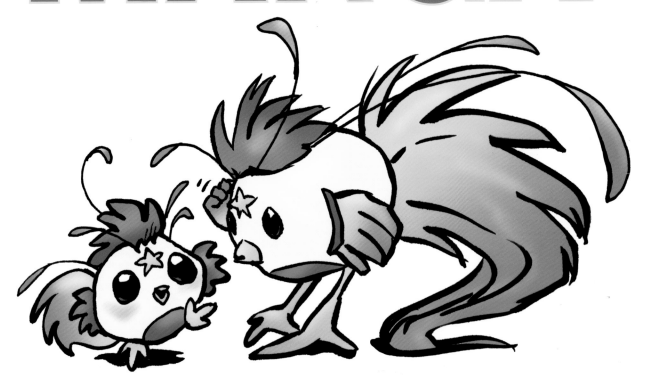

ANIMALS, CHIBIS, *AND*
OTHER ADORABLE CREATURES

J. C. AMBERLYN

WATSON–GUPTILL PUBLICATIONS/NEW YORK

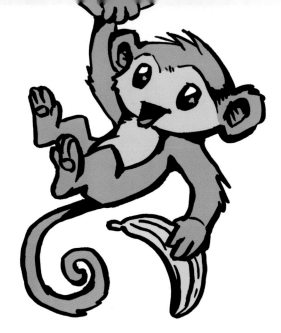

Text and illustrations copyright © 2009 J.C. Amberlyn

Designer: Lauren Monchik

First published in the United States in 2009 by Watson-Guptill Publications,
an imprint of the Crown Publishing Group, a division of Random House, Inc.,
1745 Broadway, New York, NY 10019

www.crownpublishing.com
www.watsonguptill.com

WATSON-GUPTILL is a registered trademark and the WG and Horse designs
are trademarks of Random House, Inc.

Library of Congress Cataloging-in-Publication Data

Amberlyn, J. C.
Drawing manga animals, chibis, and other adorable creatures / J.C. Amberlyn.
 p. cm.
ISBN 978-0-8230-9533-9 (alk. paper)
1. Comic books, strips, etc.--Japan--Technique. 2. Cartooning--Technique.
3. Comic strip characters--Japan. I. Title.
NC1764.5.J3A43 2009
741.5'3620952--dc22

 2009021667

Printed in China

First printing, 2009

5 6 7 8 / 16 15 14 13 12

I DEDICATE THIS BOOK TO MY MOM AND TO DEN. THANK YOU
FOR ALWAYS SUPPORTING MY ART AND FOR PROVIDING ME
WITH THE ARTISTIC WINGS TO FLY.

I WOULD ALSO LIKE TO THANK ALL THE PEOPLE WHO HAVE
ENJOYED MY ARTWORK OR ENCOURAGED ME ALONG THE
ARTISTIC JOURNEY. YOU HAVE HELPED MAKE THINGS POSSIBLE.

CONTENTS

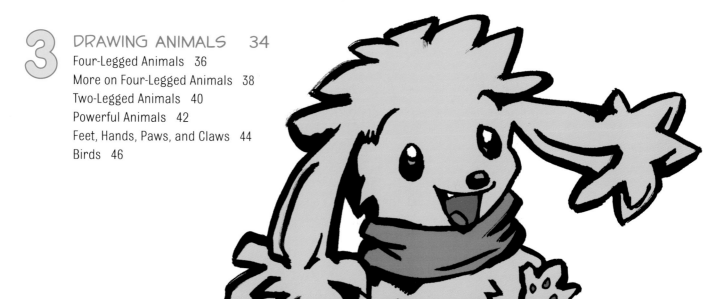

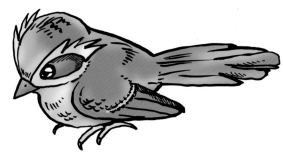

MYTHOLOGICAL AND REAL CREATURES

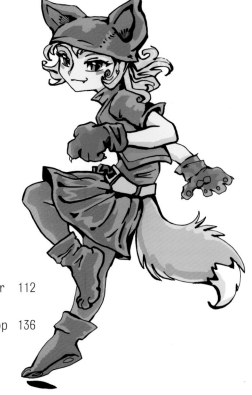

USING THE COMPUTER TO CREATE MANGA ART

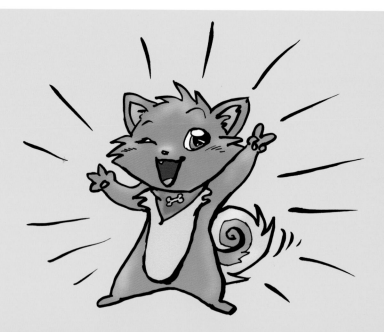

INTRODUCTION

What is it about manga-style artwork that makes it so appealing? Manga (Japanese comics) and anime (Japanese animation)—style characters are becoming popular and mainstream in many countries outside of Japan. Indeed, manga expressions and art techniques are now frequently adopted by non-Japanese artists. So what is it that has captured so many people's interest? There are a variety of factors, just as there are a variety of manga art styles. Many people are familiar with the super-cute, big-eyed characters found in anime series such as Pokémon, and that charming and appealing look is definitely a part of manga and anime's worldwide fame.

However, once a non-Japanese person begins to dig a little deeper into Japan's comic art, she will find an astonishing variety of art, stories, characters, and lore to appeal to people of all ages and inclinations. Manga includes adorable, wide-eyed characters dashing from one whimsical adventure to the next. However, it also includes stories and characters with a tough sophistication reminiscent of James Bond or John Wayne (though the characters are as likely to be samurais as they are to be spies or cowboys—perhaps a combination of both). The hard-edged, stylized

artwork of these adventures reflects their gritty and unsentimental nature. In addition, manga may include action-packed fantasy or sci-fi, romantic love stories complete with lots of sparkly eyes and flowers, or gothic tales of horror and suspense. Manga-style art seems to have something for everyone. In addition, anime and manga series often feature stories and characters that have much more depth—shades of gray, if you will—than many viewers are used to seeing in a cartoon.

Lastly, don't forget the factor of fun! A lot of anime and manga artwork seems to be brimming over with fun, innocence, and whimsy, which is appealing to many viewers. Experimenting, stylizing, and enjoying yourself and your characters is encouraged. Also, going back to those big eyes … manga and anime artists often use the expressiveness of their character's eyes and faces to create an emotional bond with viewers of their work.

The animals in these stories reflect the world they live in. Japanese manga often celebrates cuteness, so the cuter, zanier, and more "sugar-hyped" it is, the better! Many series feature a mostly human cast, but there is often one simplified animal mascot character that gives advice or companionship to the main character. More serious manga and anime feature more realistic and often dangerous-looking animals. They may be friend or foe, but are usually stylized and drawn with numerous details and layers of shadow, in contrast to the simple designs of merely cute characters. Other animal characters fall somewhere in between the two—it just depends on the needs of the artist and the world he/she wants to create.

HISTORY OF MANGA AND ANIME

As an American, I find it interesting how intertwined American and Japanese animation and comics have been and still are today. Some of the stereotypical "manga look," consisting of big eyes and really cute characters, has a partial origin in American cartoons. Osamu Tezuka, who became a great Japanese cartoonist (and is sometimes called "the father of anime"), was heavily influenced by American cartoons such as Walt Disney's 1942 animated movie *Bambi*. Tezuka was the first to establish the big-eyed, cute look in Japan—a look based on the American cartoons he loved. Many of his creations were eventually animated as television shows, and some of those shows were then broadcast on American TV—*Astro Boy* and *Kimba the White Lion* are some of his creations most familiar to American audiences.

However, some say that manga itself originated much earlier than the twentieth century. In fact, the argument can be made that manga is nearly one thousand years old! The Japanese have a long history of telling stories with pictures. In twelfth-century Japan, an artist and priest named

Bishop Toba created the Animal Scrolls, several narrative picture scrolls depicting anthropomorphic animals wearing clothes and behaving much like human beings. Also about that time, other artists illustrated the famous Japanese novel *The Tale of Genji*. Later, in the 1700s and into the 1800s, wood-block illustrations called *ukiyo-e* became very popular in Japan. They depicted the pop culture of the day: famous Kabuki theater actors, the latest fashions, and pictures that illustrated traditional stories. There were even illustrated, humorous cartoon books made in the early 1700s that may have been the world's first comic books. The trend of telling stories and having fun with pictures continued into the twentieth century, when modern manga really took off — thanks to artists such as Tezuka.

Today, manga is a big part of Japanese daily life, and it's not just for kids. Many adults like to read manga and watch anime, and some series are created just for them. I know that in America, cartoons and comics have usually been relegated to the realm of kiddie stuff, but that is slowly changing—partially thanks to anime and manga. More adults than ever are finding they enjoy some of these stories, too. It appears that the future of manga and anime, both inside and outside of Japan, is very bright indeed.

ABOUT THIS BOOK

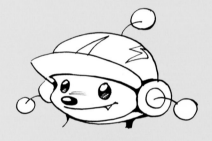

It is my hope that this book will benefit all artists interested in learning more about the Japanese style of drawing and the culture that influences it, whether they want to draw cute and simple mascot-like creatures or more complex animals like an Asian dragon. This book aims to provide something for all skill levels. The first section (Chapters 1 through 5) covers the basics of creating manga-style characters—everything from drawing heads and faces, eyes and expressions, to creating the incredibly cute, dwarf-like chibi characters that are beloved icons of the manga style.

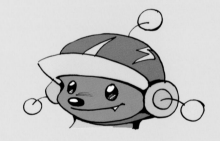

I am not an expert on Japan itself. However, I have spent my teenage years and entire adult life studying, emulating the art style of, and enjoying anime and manga, all the while trying to learn something about the rich and fascinating Japanese culture it comes from. The second section (Chapters 6 and 7) focuses on the mythology and cultural impact of animals, both real and imagined, that have shaped Japanese artwork and stories. Learning about these influences gives one a greater understanding of common themes and character types seen in manga and anime. This knowledge is likely to increase one's

enjoyment of the art form, whether creating one's own art or simply reading a favorite manga series. This part of the book can give you, the reader, a reference guide for creating your own manga art, stories, or characters with an authentic Japanese feel to them.

Computers are an important part of many artists' work today, and so the final section (Chapter 8) includes step-by-step information on using computers to create your own manga art and comics.

Featured throughout are a menagerie of my manga-style characters: Lyra, who is a very manga-inspired "magical pretty girl" and her two animal companions, Space Chicken and Space Weasel. Watch out for that weasel, though—he's a feisty one!

ART SUPPLIES

When getting ready to create manga-style artwork, you should buy the best supplies you can afford. That goes for any computer purchases you may consider as well. If you are using paper to draw, you'll want to be sure to look for acid-free paper so that your drawings don't become yellow with age. Some drawing pads on the market are made specifically with manga artists in mind. I suggest getting a professional drawing pad with Bristol board or, if you cannot find Bristol board, a high-quality drawing paper for creating your finished artwork. You can also get an artists' sketchbook (for sketching, I use the Watson-Guptill sketchbook, which is made of archival-quality paper and has a nice, hard cover). If you are drawing straight onto the computer, an artist's graphics tablet can be of great help. Trying to draw with a computer mouse is awkward for many people. With a graphics tablet, however, you can use a stylus to draw onto the tablet much like how you'd use a pen on paper. I often used a Wacom tablet when working on this book, especially when I was coloring in details.

You will also want to look for the label "acid-free" or "archival" when selecting pens. This will ensure that your linework doesn't fade over time. Many high-quality pens are available on the market. In creating this book, I used primarily two brands. One was a Copic brand marker, which is made in Japan and often used by Japanese *manga-ka* (comic artists) to create manga. I used a 100 Black Copic Sketch Marker to get a brush tip that gave me lines of varying thickness and thinness, depending on how I applied pressure and brushstrokes. Varying lines add interest and depth to a drawing, but they can also be a bit more difficult to control. In addition, I used Pigma Micron pens (03, 05, and 08) when I wanted to get a line exactly right.

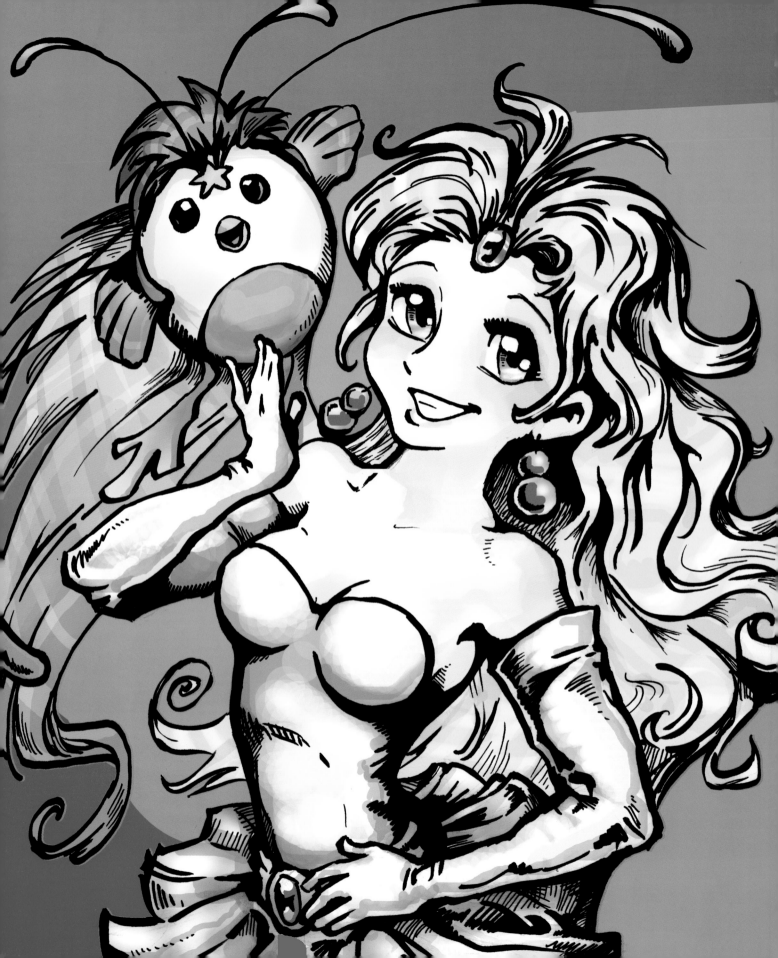

THE BASICS OF CREATING MANGA-STYLE CHARACTERS

DRAWING
HEADS, FACES, AND EXPRESSIONS

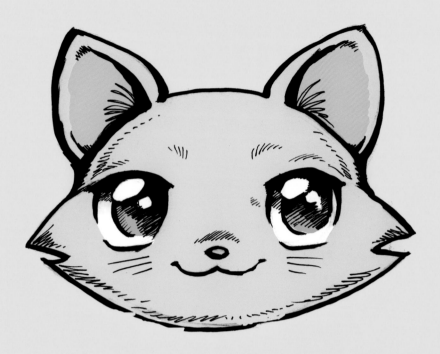

Manga-style heads and faces

reflect the style of the artist who draws them, whether that means cute and zany or gothic and dramatic. Regardless of style, some basic techniques are helpful for any artist to know. All heads, on some basic level, can be modeled after a geometric shape or pattern such as a circle or an egg. Some heads may be realistically drawn, and others may have very cartoon-like, exaggerated, or simple shapes. Simple shapes can work well for depicting the raw energy and sheer cuteness of many manga mascots and chibi characters. Complex shapes lend themselves to more realistic or mature characters.

Expressions can be used to convey a character's basic personality. A whimsical, cheerful character is often depicted with an open, smiling mouth. A laid-back or mysterious manga character may be depicted with closed eyes that open only when the character becomes agitated or intent about something.

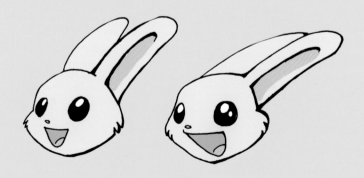

SIMPLE CARTOON HEAD SHAPES

Here are some simple head shapes that are often used for mascot and chibi characters.

FRONT VIEW

A basic cartoon animal-head shape utilizies a circular/oval shape. Note that the eyes and mouth are spaced about one eye-width apart, although this arrangement can vary according to the look you want to achieve.

I've added highlights and eyelids to the eyes, a nose, and blocked out where the top of the ears will show on the head.

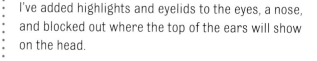

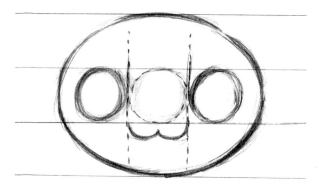

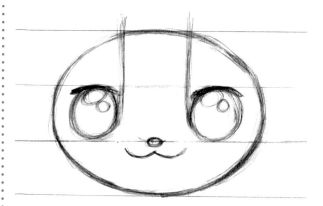

I decided to make this a cat. I blocked in the shape of the ears, the ruff of fur along the cheeks, and refined more of the face and eyes.

I added some lines to indicate fur, the muzzle, and whiskers. Then I inked the final version and erased the pencil lines.

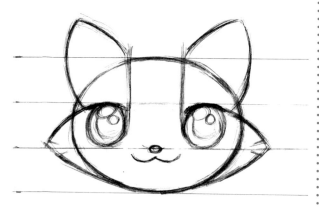

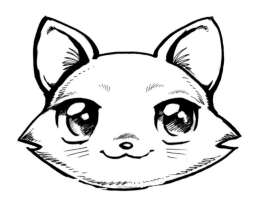

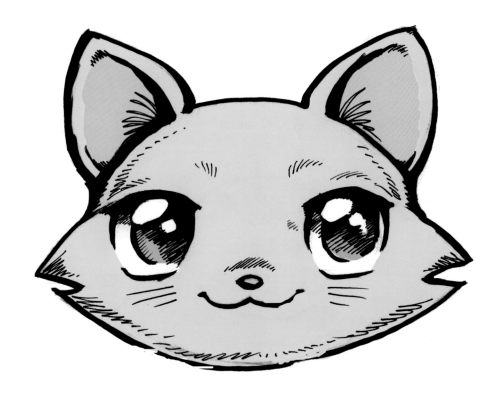

This basic head shape can be used to create many different cartoon animals, ranging from mice to elephants. You can create many different species just by changing the ears, nose shape, and other elements. For instance, some animals have long noses, some have round eyes, and others have slanted ones. Practice making the animal of your choice.

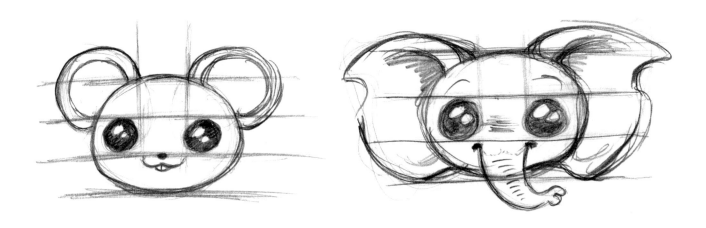

EARS AND OTHER ELEMENTS

Here are some tips on placing the ears and other elements onto the head.

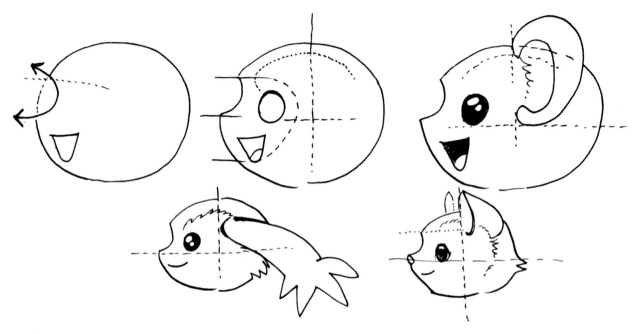

Many (but not all) cute manga- and anime-style characters have simply drawn mouths and chins, with stylized lines and no evidence of lips from the side. In the top example, the lower base of the ears is placed in the center of the head shape. Other characters' ears might be placed differently, as you can see from the other two examples.

In the illustration below, two different examples (one using dotted lines) for how the base of the ears might be placed on the head are shown.

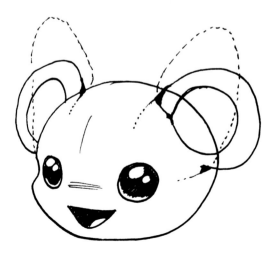

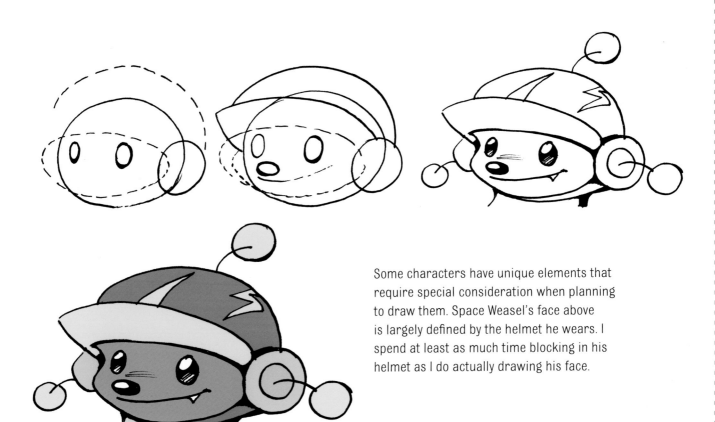

Some characters have unique elements that require special consideration when planning to draw them. Space Weasel's face above is largely defined by the helmet he wears. I spend at least as much time blocking in his helmet as I do actually drawing his face.

Space Weasel's helmet also hides any eyebrows he might have, which would help us to gauge his expression. I often use the helmet visor just above his eyes as substitute eyebrows. The way I position his head affects the angle of the visor, and thus his expression. However, sometimes I just have to get creative, like with this drawing. I wanted a perplexed look, but couldn't draw furrowed eyebrows. Instead, I used the lightning-bolt design on his helmet to draw a furrowed eyebrow—like line (the heavy line at the end of the lightning bolt right above his eye) to show where his eyebrow might be. It's very subtle but expressive.

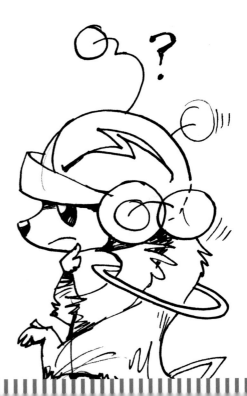

HUMANOID HEAD SHAPES

Humanoid creatures resemble humans yet are not quite human themselves. They can also be called anthropomorphic. Cat girls and other familiar manga characters fit into this category.

FRONT VIEW

This basic head shape is formed using the underlying structure of a vertically-aligned oval. I tapered the "chin" of the oval to a point. The eyes are slightly wider on top than on bottom, echoing the head shape. (For more detail on drawing eyes, see Chapter 2.) Note that some manga-style heads have more of a heart-shape to them, giving them a wider forehead than jawline.

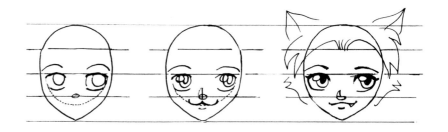

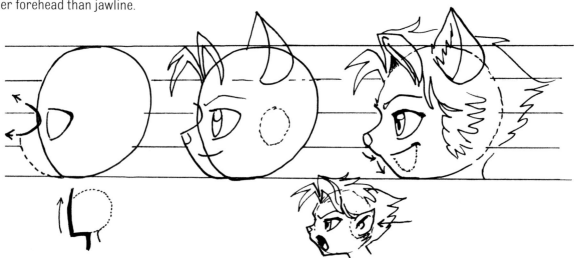

SIDE VIEW

In profile, many manga characters are either drawn with only minimal indications of lips or no evidence of them whatsoever. When starting your drawing, keep in mind that humans have large brain cases and comparatively small faces. Also note the sharpness of the chin in profile. In the second step, I used a dotted line to indicate where the ears would go if the character were more human-like but drew the actual ears on top of the head to appear more cat-like. The dotted line under the mouth on the third step indicates where I would draw the mouth if it were open. The example underneath indicates a more human-like character with an open mouth.

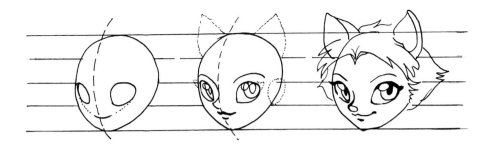

THREE-QUARTER VIEW

In the second step, I've included a dotted oval showing where a human ear would go.

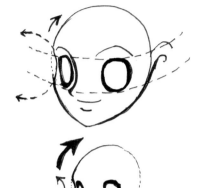

FAR SIDE OF OVAL FACE

When drawing the far side of the face, the eye socket will occupy an indentation, or hollow. Drawing this hollow makes the outline of the cheek below and the eyebrow above seem to jut out, adding dimension to the face. Other than this hollowed-in area of the eye socket, the oval-shaped facial outline of the far side is depicted as one continuous rounded line, sweeping its way up the chin and continuing above the eye socket to bend up and back, toward the top of the head.

FAR SIDE OF HEART-SHAPED FACES

Many Japanese manga characters are drawn with more heart-shaped faces than oval ones, such as this example. The basic setup is the same—an oval head with a pointed chin—but the difference lies at, and just above, the eye socket. The outline of the far side of the forehead is drawn with an upward sweep of the pen, which does not continue the rounded shape going past the eye, up the forehead, and to the top. Instead, it sweeps straight up at the eyebrow, where it either meets and ends at the hairline or sweeps back toward the top of the head from a much higher point. This adds visual space to the outer side of the eyes, enlarges the forehead, and results in a less "cramped" feel.

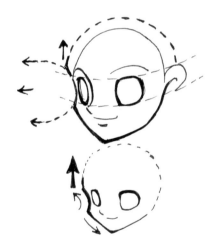

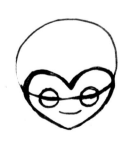

Another heart- or egg-shaped face. You can also think of an owl's face to help you visualize the structure.

19

REALISTIC, LONG-MUZZLED ANIMAL HEAD SHAPES

Many animals such as horses, foxes, lizards, and bears have long muzzles, or "noses." Knowing how to draw these animals correctly may require study on your part to depict them accurately. It helps to know the anatomy of real animals; for instance, how the skull and teeth shape what you see on the surface. This study also helps when you try to visualize the anatomy of mythological creatures, such as dragons.

FOX HEAD

This fox's head is noticeably shaped by the contours of the skull underneath. Pay attention to proportions Part of making the drawing look "right" is getting the correct size and shape of the animal's muzzle as compared with the rest of its head. If the drawing doesn't look right to you, consider whether the muzzle is too short, too long, too thick, or too thin.

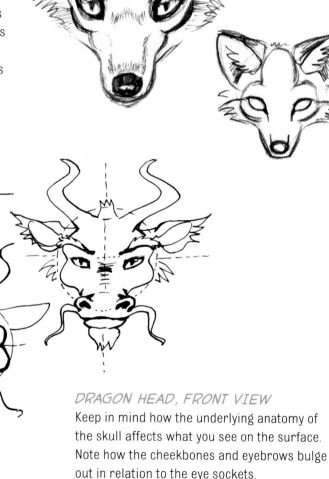

DRAGON HEAD, FRONT VIEW

Keep in mind how the underlying anatomy of the skull affects what you see on the surface. Note how the cheekbones and eyebrows bulge out in relation to the eye sockets.

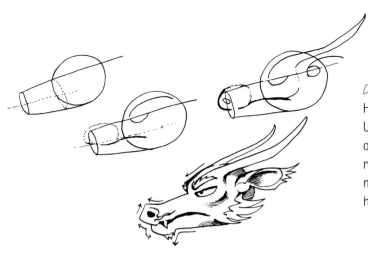

DRAGON HEAD, SIDE VIEW

Here is just one way to draw a dragon's head. Use your imagination in order to create an array of creatures: cuter dragons with bigger and rounder eyes, stockier dragons with shorter muzzles, fiercer dragons with more elaborate horns and spikes, etc.

DRAGON HEAD, THREE-QUARTER VIEW

Note how the bottom of the snout flows into the shape of the jaw.

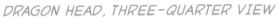

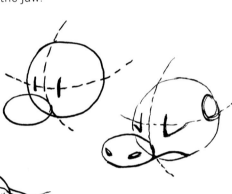

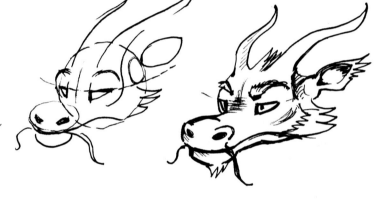

MORE MUZZLED ANIMALS

Here are some other side views of animals that feature longer or thicker muzzles. With some animals, such as the horse, the muzzle dominates the face.

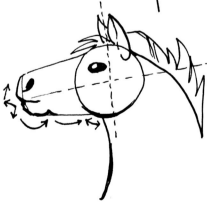

FACIAL FEATURES

Facial features can be fun to draw. The nose, the mouth—and of course, fangs—can be used to add life and character to any drawing. The eyes are so important that they are covered in a chapter of their own (see Chapter 2 on page 26).

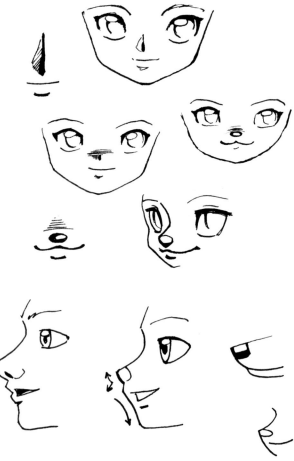

NOSES

Manga-style noses are well known for being small, simple, and stylized compared with realistic ones. Many human, or human-like, characters have noses rendered with a very simple curved line or triangular shape. Cute animals are usually made even simpler, with small button noses or no nose at all. More realistic manga animals may sometimes have larger and more detailed noses, but they are still usually simplified in appearance.

MOUTHS

Mouths are also usually drawn in a simple and stylized fashion. Many manga-style mouths are small (compared with the eyes) unless they are open and exaggerated to convey an expression like excitement or happiness. When a manga-style character is drawn in an excited, cute, angry, or "chibi" moment, all bets on realistic anatomy are off! Then, the outline of the lower part of the mouth may reach beyond the outline of the chin. It's not realistic, of course, but it works in the wacky world of manga.

Space Weasel's mouth extends below his bottom jawline. Note how I left a part of the mouth's farthest corner unfinished. If the mouth were finished and completely darkened in, it might appear heavy and flat. Leaving that one part lighter makes it look as though it's receding into the distance, thereby adding a little dimension.

MORE ON MOUTHS

Here, I've shown how I make a character go from mildly happy to wildly so by exaggerating the angle of the mouth in relation to the eyes. The "mild" character (top) has a simple, happy mouth shape. For the more excited, "wild" (bottom) character, I did several things. I stretched the bottom of the mouth farther down and back, widened the distance between the eyes, and pulled the ears back as if the character were leaping through the air, having its ears pushed back by the wind. I also added extra highlights in the eyes for sparkle.

FANGS

Another common element in manga is the use of "fangs." Cute characters (even human ones that shouldn't actually have any sharp canine teeth) are sometimes drawn with an impish-looking fang. This fang is commonly shown on only one side of the mouth. It often is used to depict a more edgy (yet still cute) mood, such as mischievousness (shown here) or playfulness, or to indicate that a character is angry. Some manga artists may suddenly depict their character with a fang and cat ears during an especially cute moment, and then show that character back to normal in the next panel. This is one of those typically manga moments that might look strange in an American-style comic book but seems to work quite well in the world of manga.

EXPRESSIONS

Manga characters feature a variety of distinctive expressions—from the nervous "sweat drop" to the "popped vein" of anger, and many moods in between. Expressions can change in an instant and be highly exaggerated in the more zany or humorous stories. Here are some of the more common emotions and expressions seen in manga.

SHOCKED/FRIGHTENED

Squiggly eyes drawn without pupils can signify shock, illness, or a confused or clueless character. Lines across the face indicate a character ill at ease.

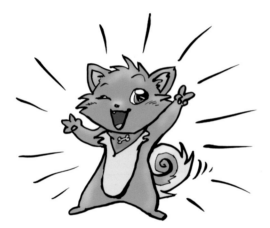

HAPPY

A happy character will smile, of course. It may also wink and hold out a friendly hand or paw in a "V" sign.

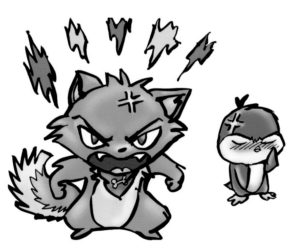

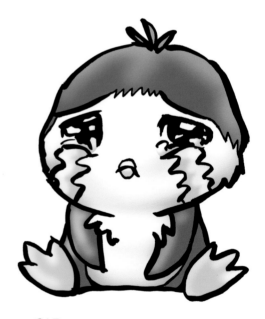

ANGRY

The more enraged a character gets, the more his or her features distort and the more exaggerated the eyes and mouth should be. The plus-shaped mark on the dog's forehead is a "popped vein," which is commonly seen in manga artwork. The penguin on the right is not quite as angry as the dog, though the popped vein does indicate annoyance.

SAD

A sad character's eyes become watery (as indicated by lots of highlights depicting excess moisture) and overflow with tears. Heartbroken characters may have a virtual flood of tears coming out of their eyes!

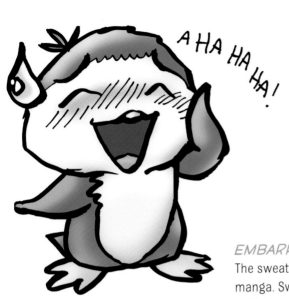

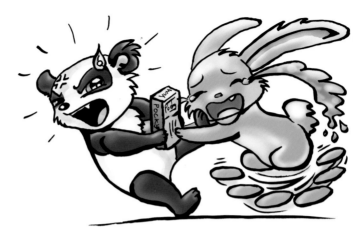

EMBARRASSED/NERVOUS

The sweat drop on the side of this penguin's head is a familiar feature in anime and manga. Sweat drops indicate the character is breaking a sweat, or becoming nervous or flustered. They may even be inclined toward nervous laughter.

Above and to the right, several of the previous expressions are combined in one drawing. Note the annoyed panda bear's flustered sweat drop and annoyed popped vein. Meanwhile, the rabbit cries a flood of tears and has a highly exaggerated mouth.

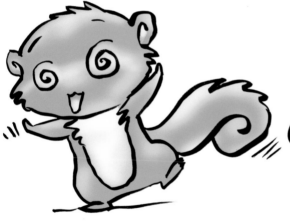

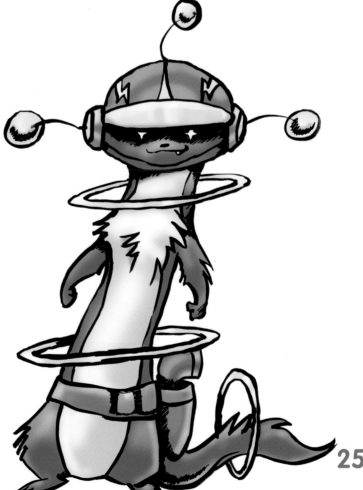

KNOCKED OUT/SPACED OUT

Spiral-shaped eyes show a character who has been thrown for a loop.

MISCHIEVOUS

Space Weasel's face is masked in shadow as his eyes seem to glow in the darkness. He's probably up to no good! This effect can add a sense of mystery, mischievousness, or malice to a character.

DRAWING EYES

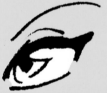

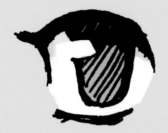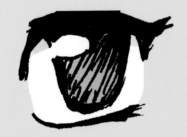

Manga is well known for its large-eyed characters,
so getting the eyes right is a vital component in creating a compelling drawing.
However, not all manga characters have large eyes: It depends on the character
and what the artist is trying to convey about them. Eyes are often used to show
a character's personality. For example, sweet, innocent characters often have
huge, sparkling eyes, while more serious and mature characters may have
miniature, fierce-looking ones. The way the eyes are drawn may also change
depending on the mood of the character, often giving an exaggerated and
comedic effect. Cute animals and mascots are often portrayed with simple black
or beady eyes, especially if the animal is a secondary, supporting character.
Main characters get the most complex and visually engaging eyes, while
supportive characters' eyes are usually drawn much more simply.

Manga animal eyes come in all shapes and sizes. Some look more human,
with eyebrows above, prominent eyelashes around, and an iris and pupil within.
Others may have no iris and only a simple pupil; some may be entirely one color,
or they may be dark and beady. Eyes appear moist, and highlights (white spots
or streaks) are used to emphasize that moisture and bring a spark of life.

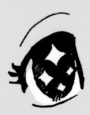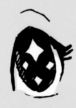

BASIC MANGA EYES

A very common and distinctive feature of manga-style eyes (especially the more human-like ones) is that they are usually not drawn with a solid, continuous outline. Although some heavy lines are drawn on the top and bottom of the eye where the eyelashes would be most visible, solid lines are usually absent at the inner, and sometimes the outer, corners of the eye. If the *manga-ka* (comic artist) goes back to his inked drawing later with the intention of coloring it, he will do so without adding any unnecessary outline to those corners.

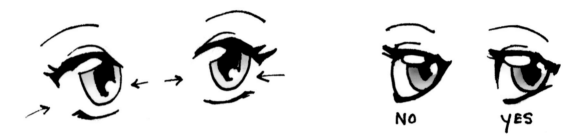

In the drawing shown above, note the arrows pointing to the absence of outlines at the eye corners. Broken outlines for eyes are common in manga, but solid outlines for eyes can be used, too.

BASIC SHAPE
To draw a manga-style eye, start by making a horizontal oval. It will resemble a basic, human-like eye.

IRIS AND PUPIL
Here, I have used broken lines to show how the iris continues under the top eyelid. Cutting off the iris at the top gives the sense of a three-dimensional drooping eyelid. Also note that I drew the iris and pupil with a slightly vertical oval shape—a style frequently found in manga artwork.

ADD HIGHLIGHTS

In most manga drawings, there will be one larger highlight and one or several smaller highlights. Drawing the larger highlight so that it overlaps the pupil, iris, and eyeball helps create a sense of light reflecting off the surface of the eye. Also, be sure to add the upper and lower eyelashes.

INK IN YOUR DRAWING

At this point, I inked in the drawing, erasing the pencil lines afterwards. An alternative to using ink is to simply darken your pencil lines and erase where needed.

If you want to take your drawing further, add some details in the area of the iris or eyelashes, for instance, by adding an eyelid or an eyebrow above.

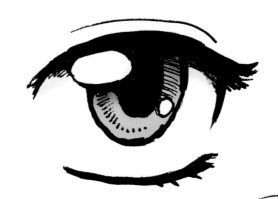

BEADY EYES

A beady eye goes well with a cute miniature animal, monster, or mascot. This simple eye was created with a circle, a few highlights blocked in, and then darkening the eye. Note that I left a little cross-hatched area at the bottom left to indicate light streaming into the eyeball and to give it a little more dimension.

SHOUJO EYES: GIRLS' MANGA

There are many ways to draw manga-style eyes. The way manga-ka draw eyes often depends on the sort of story they are creating, as well as the personality of the character. *Shoujo* manga (girls' manga) is often full of wide-eyed characters whose faces convey much emotion. Feminine eyes are often portrayed as large, round, and expressive, while masculine eyes are usually more angular.

The innocent nature of this character is conveyed by her large, widely set apart eyes and cute smile

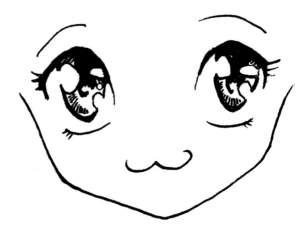

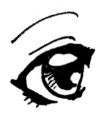

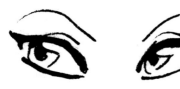

HUGE, SPARKLY EYES

Sweetly innocent characters have huge, sparkly eyes. The bigger the eyes, the more harmless the character appears.

In manga, the slant of a character's eyes says a lot about their personality. Characters with droopy-looking eyes (upper left) tend towards sleepiness, sadness, or have a relaxed or child-like attitude. Characters with outer eye corners that slant upwards (bottom left) have a penchant for mischievousness, or they might be clever, saucy, or sassy.

CUTE, BEADY EYES

Remember to keep the eyes wide enough apart to convey an innocent vibe. A pert mouth adds to the charm. Note the absence of a nose, which may not be needed on a simpler, merely cute character.

DREAMY EYES

Don't forget that in manga, eyes can change quite a bit depending on the mood of the character. This is especially true if the manga is a comedy or has light-hearted moments when characters can morph into chibi form at any moment (see Chapter 4). At that point, the character's eyes will reflect his or her mood, often to comedic effect. Here is a starry-eyed moment as a character gets all dreamy and idealistic. (See also pages 24–25.)

SHOUNEN EYES: BOYS' MANGA

The characters in *Shounen* manga, or boys' manga, often are depicted with somewhat smaller eyes that are more angular and fierce-looking than those of the characters in Shoujo, or girls', manga. Masculine eyes are often shown with pupils that are smaller in comparison with the rest of the eye, and the eyebrows are usually thicker and more defined. However, in manga, a young boy also may have huge, expressive eyes—much like a girl's. So study real-life eyes, and familiarize yourself with the work of other manga artists. If you're not sure what type of manga you're working on (or don't care to classify it), then take each individual character and design the eyes according to his or her own personality.

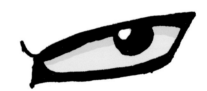

FIERCE EYES
By making the eyes more angular and downplaying the pupils, you can make the eyes look fierce.

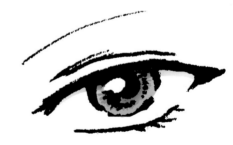

BLANK EYES
Another choice you have is to deemphasize the pupils, or leave them out entirely. Characters with these almost "blank" eyes may come across as distant and ghostly, or they may take on a dazed or even ethereal look, depending on their overall character design.

HUMAN—LIKE EYES
A more human-like eye with a detailed iris and eyebrow is shown here. Add eyelashes, creases to the eyelid, and a small iris and pupil to achieve a realistic look.

CONCAVE EYES

Eyes are fun to illustrate because there are many ways to draw them. There is one manga-based technique of drawing eyes that any aspiring manga-ka should know, even if they choose not to use it: the so-called concave eye. As you know, real eyeballs are convex, meaning that they curve outward and protrude from the eye socket (upper right drawing). When drawing realistically, this is how you should render them. However, one manga technique is to draw the eyes as if they were concave, or curved inward, rather than bulging outward (bottom right drawing).

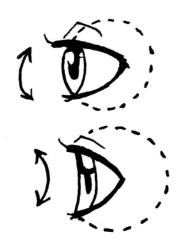

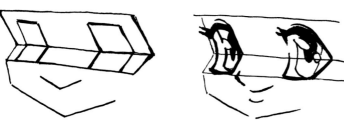

To further illustrate the concave method of drawing eyes, take a look at this three-quarter view of a robot-like head and its simplified shapes. Note how the eyes appear as though they are lying flat on the surface of both the upper and lower levels of the sockets, rather than protruding from them realistically. In such a drawing, the irises and pupils often lean toward a vertical-oval shape, but frequently are concave just like the eyeballs.

These are highly exaggerated drawings (frequently, manga-style concave eyes are not so obvious). But if you look for the concave eye technique in Japanese manga, you'll find it popping up in lots of places. You can take this style or leave it, but it is helpful to be aware of it. It can add a highly stylized, pure manga feel to your drawings when done right.

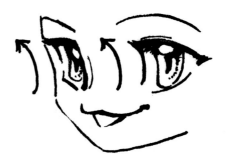

DRAWING
ANIMALS

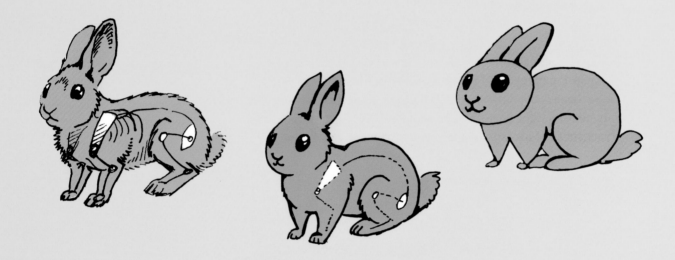

The main thing you can do to improve your technique for drawing any living subject is to study anatomy. Study from real-life subjects when possible, including pets, zoo animals, wild animals, and other creatures. Don't neglect to study human anatomy, including your own in the mirror. Learn from photographs, too, but be aware that they can convey distortions due to the lens used, distance of the subject to the camera, or other factors.

The more you know the rules, the more successfully you can break them later to create art that is uniquely your own. Even though manga is heavily stylized, successful manga-ka have a basic knowledge of anatomy that allows them to exaggerate form in a fresh, new way while keeping it in the realm of believability. There's enough of a grain of truth behind their characters' exaggerations to keep them convincing and real.

FOUR-LEGGED ANIMALS

Four-legged animals tend to have shoulders, hips, and a backbone—much like a human does—which is spread out horizontally rather than vertically. All four feet provide balance, so getting the legs and joints/sockets right (including the shoulders and hips) is critical for a correct sense of anatomy and for conveying mood and action.

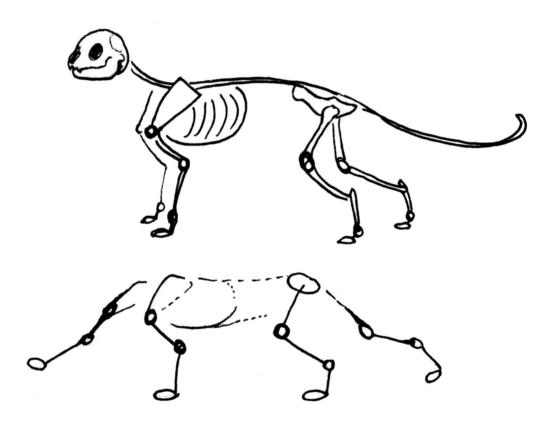

SIMPLIFIED SKELETAL STRUCTURE OF A CAT

This drawing of a cat shows the basics of anatomical structure: the skull, backbone, ribs, and the legs and their attaching joints and sockets. The placement of the backbone is key because it lends a sense of movement to your figure and determines the placement of all the other parts. The position of the head imparts mood—head up high means confident, head down low means suspicious, embarrassed, or sad, etc.

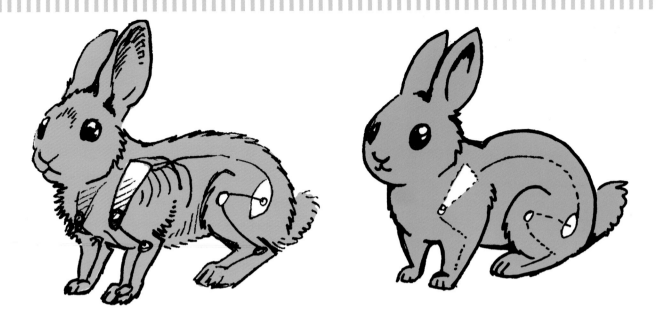

SIMPLIFIED RABBIT

Here I show some steps to take when simplifying the figure of a rabbit. On the left is a realistically drawn rabbit in which I've shown a hint of where the basic body parts, such as shoulder blades and hips, would go. I used detailed lines to suggest depth of fur and toes. On the right is a more simplified rabbit. Using the same basic structure, I've cleaned up the lines to use as few strokes as possible while retaining a believable bunny shape. I also added a bit of a smile to the rabbit's lips and simplified the toes and ears.

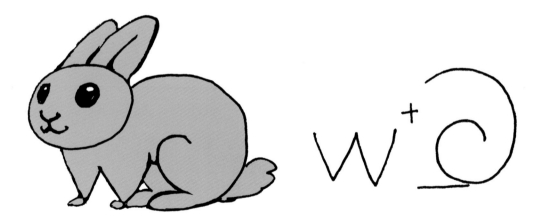

I've simplified the same rabbit yet again. This shape, while quite cartoon-like in appearance, is still based on the anatomical structure of the previous two drawings above. Thus, it remains believable as a rabbit even though it is highly exaggerated. In it, the body is reduced to two simple shapes: a W plus a spiral. The farthest eye is not entirely round but flattened near where the bridge of the nose would be. This detail gives the otherwise two-dimensional shape of this rabbit's head an appearance of depth. This is an example of how one can use knowledge of anatomy to add realism and depth to a figure that is otherwise very stylized and lacking in detail.

MORE ON FOUR-LEGGED ANIMALS

Once you've mastered the basics of anatomy you can explore ways to stretch or exaggerate the features of each animal in order to convey its unique personality.

CONVEY SOME PERSONALITY

Here I've drawn a basic cat-like body (top) with fairly normal-looking anatomy. Sometimes this is all you need. However, if you are coming up with an animal character you plan on drawing again and again, you may want it to stand out as unique and to convey a bit of its personality in the way you draw it.

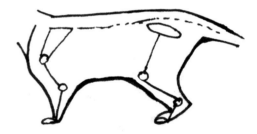

This is what I've done in the next two drawings by exaggerating selected features of a cat's anatomy. The cat in the middle is sleek, fat, and solid. I used a bare minimum of lines to depict its short legs. The underlying anatomy doesn't show much through its fat, muscles, and fur, and the lack of sharp angles contributes to its sleek, well-fed appearance. This might be an elegant, pampered pet.

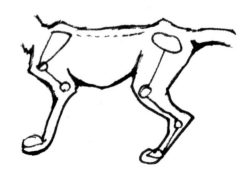

The cat on the bottom is far from sleek. It has a rangy, scruffy look due to the exaggeration of the joints in its legs, the scribbled lines that suggest unkempt fur, and its angular depiction. In addition, I've given it proportionally long legs and large feet, adding to its awkwardness. This might be a young alley cat that's seen better days.

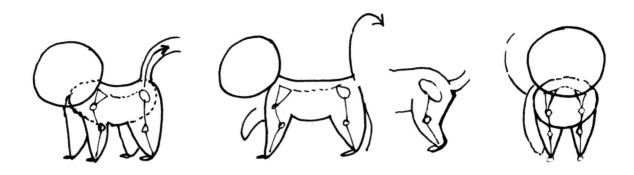

STYLIZED ANIMALS

Many manga animals are stylized to form relatively simple shapes, such as the figure shown above in three-quarter (left), side (middle), and front view (right). Cute characters are often drawn in such a basic manner. The artist chooses how much anatomy (muscles, fur, elbows, ribs, etc.) to depict. The more anatomy you include, the more realistic your figure will become. The most basic body features include a tube-shape for the legs, feet, and very simple lines indicating the stomach and back.

Many animals walk on their toes, not on their heels like humans do. The heel of the foot usually points up and behind the animal. However, some artists draw the hind legs of a very stylized animal in the same way they draw the front legs—with no indication of the heel of the back foot. (See the hind leg comparison in the side view of the figure above. The whole-body drawing shows this straight-leg simplification, while the small drawing to its right shows the hind leg with a heel protruding.)

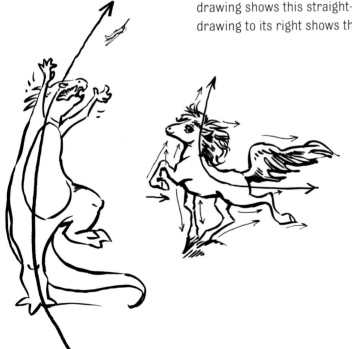

ACTION LINES

Action lines convey the main thrust of a figure's movement. As you can see from the arrow, the thrust of the reptilian monster's movement follows its spine as it reaches as high as it can for that pesky airplane.

The pony trots along with a proud, arched neck. Note how the main thrust of movement (shown by the action line) is echoed throughout the rest of the drawing with lines (indicated by smaller arrows) that flow in the same directions. Lines that reinforce each other add an increased sense of cohesion and force to the figure.

TWO-LEGGED ANIMALS

Two-legged manga animals are often based on a simplified bipedal human structure, featuring a torso with two arms above, two legs below, and a head on top. Depending on the realism desired, the arms and legs may display muscles and angles, or they may be simplified tubes, which narrow down to where the hands would be. Often the feet are quite small or may even be nonexistent. In reality, such a creature would have a hard time supporting its own weight, but this isn't usually a consideration in the more stylized world of manga.

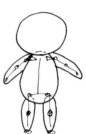

Here is an adorable two-legged figure showing basic body, hip, and shoulder structure in three-quarter, side, and front view. Note its enlarged head, tiny, almost nonexistent hands, and itty-bitty feet.

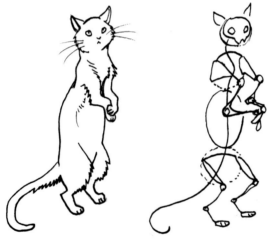

HIND LEGS

Drawing a realistic animal that happens to be standing on its hind feet requires that you study real animal anatomy. In this case, the tail helps to add a sense of balance to the figure, as do the hips and hind legs, which are set low to the ground.

HIPS AND SHOULDERS

The hips and shoulders are important for getting the right sense of balance in a drawing of a two-legged creature. Knowledge of human anatomy helps here. Sometimes looking in a mirror can give you the information you need. For the most dynamic or lively figures, show the shoulders and hips at different angles (as shown at left).

When hips and shoulders are parallel to each other, the figure looks more stationary (as shown at right).

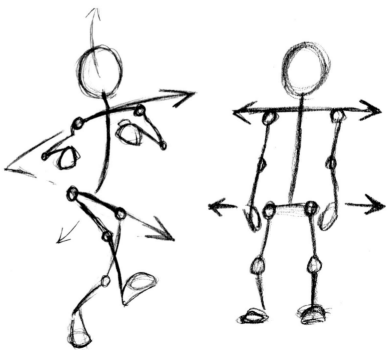

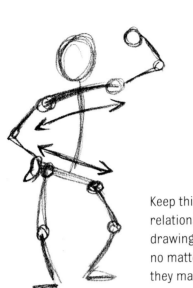

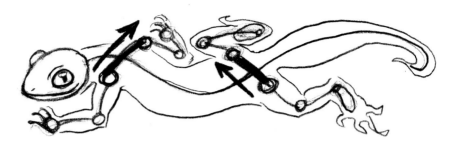

This hip-shoulder relationship applies to four-legged animals as well.

Keep this hip-shoulder relationship in mind when drawing two-legged figures, no matter how simplified they may be. The underlying dynamics shown by anatomy usually remain the same.

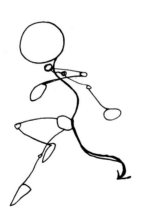

TAIL

If the creature has a tail, it is usually shown as an extension of where the backbone would be. Tails can add interest and indicate mood in a two-legged figure. The ever-popular "cat girls," *kitsunes* (foxes) like this one, and other figures, usually sport a tail and ears even if they have no other animal-like features.

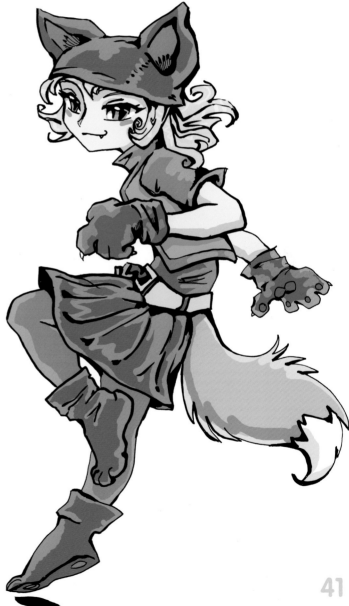

POWERFUL ANIMALS

Manga and anime animals are often endearing. Large-eyed, bouncy, with oversized heads, they are the familiar faces of the style to many. But they are not the only style. Manga includes all kinds of stories, characters, monsters, and moods. Many fantasy-based Shounen stories include gritty tales of monstrous beasts and incredible battles. And Shoujo manga can feature fearsome creatures and epic battles as well. The animals may be guardians who protect the heroes or monsters that battle whomever comes across their path. Good, bad, or just indifferent, they are powerful creatures that eat cute for breakfast!

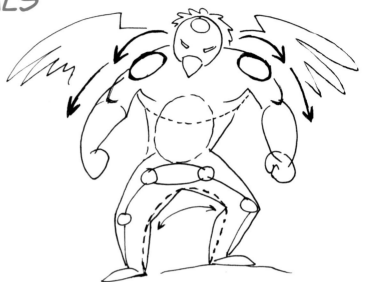

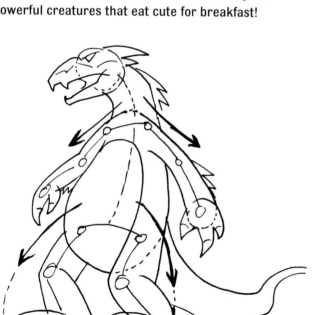

This reptilian figure also features the arch of power and stability, but in a bottom-heavy form. His center of gravity is lower, more in his hips, and his movements swing from there. Note the arrows, which indicate the arch shapes of his shoulders and his hips, which are much larger. His legs are his most powerful feature, though it looks as though his arms aren't exactly string beans!

TOUGH GUYS

One consideration when drawing a powerful two-legged creature is whether it ought to be shoulder- or hip-heavy. The stereotypical "tough guy" of any species is often broad-shouldered, with immense upper body strength, such as the *tengu* shown here (a birdman-like spirit of Japanese legend). Note the arrows, indicating the "flow" of this drawing and its emphasis on his arms. His chest is wide, too, and his head relatively small. The tengu's hips and legs are proportionally much smaller than his shoulders. His center of gravity is located somewhere in his upper torso, so his movements "swing" from that center.

The other power factor here is the arch-like shape that echoes through the drawing. The tengu's arms form such a shape, and his legs echo it (the dotted line and arrow in his lower legs emphasize this secondary arch). An arch suggests feet firmly planted on the ground, ready to withstand any impact. It is a shape that conveys power and stability.

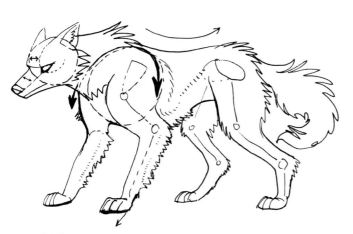

WOLF

Four-legged animals can convey a sense of strength as well. Here, I have drawn a wolf that is normally proportioned. His front legs both face the same direction, as though he is ready to spring into action at any moment. He is strong, but not as powerful-looking as the wolf to the right.

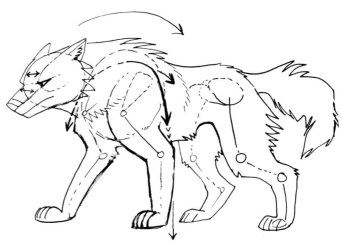

FIERCE WOLF

This wolf is highly exaggerated in order to look muscular and powerful. His face and head have been broadened, as have his legs. (Be careful not to broaden them too much, or he'll start to look like a bear!) His ears and eyes are proportionally smaller compared with the rest of his head than the first wolf's features. His front legs have been drawn wide, in the arch shape, giving the impression of holding up a lot of weight. I emphasized his shoulders by sweeping the outline of his neck up and over them, making them the highest point of his body, then down across his back and to his hips, which are placed much lower.

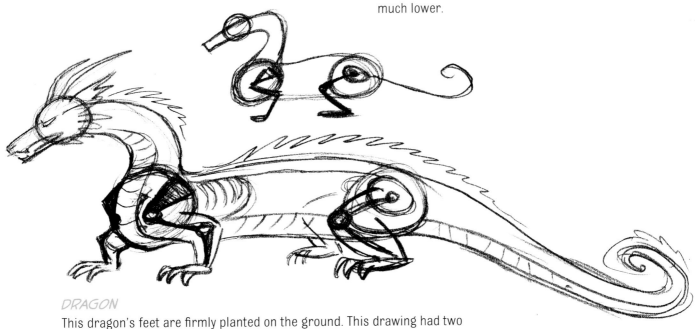

DRAGON

This dragon's feet are firmly planted on the ground. This drawing had two goals: one, a sense of power and weight, and two, a reptilian look, shown by squatting, with the legs out to the side. The dragon's body is similar to other four-legged creatures but stretched out, with a long torso.

FEET, HANDS, PAWS, AND CLAWS

Manga animal feet, or paws, range in style from the most cartoon-like and simplistic to the incredibly detailed and realistic. Your own hands and feet can provide useful models. Also, study the feet of pets to gain insight into animal anatomy.

Very simple hands can be created using ovals and circles, with simple spikes as fingers or claws.

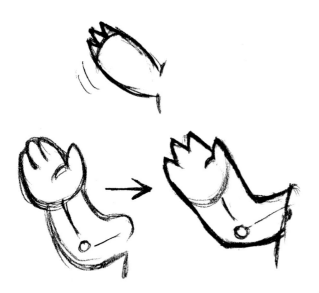

SIMPLIFIED HANDS

Effective drawings of stylized characters often conceal the fact that the artist has used his or her knowledge of anatomy to simplify and select just what is and isn't shown. The drawing on the bottom left shows a cartoon-like hand waving at the viewer. The arm on the top is further simplified—it has few lines and no indication of an elbow, though it does convey the basic idea of a wave. However, I prefer the image on the bottom right. It is very simple but contains enough information to keep it interesting. Note that the outline of the hand blends smoothly into the outline of the arm. I chose to keep the forearm thick so that the elbow juts out a bit more past its joint than it might appear realistically. The upper arm is thin by comparison. The one detail I have kept is the thumb, to add a bit of depth to the hand, which is otherwise drawn with simple spikes as fingers.

Here is another example of a simplified cartoon hand. If you're having trouble getting the scaled-down look you want, try drawing a more anatomically correct version of your animal character, and then do another drawing that simplifies it a bit more. Keep at it until you've reached the level of "simple but interesting."

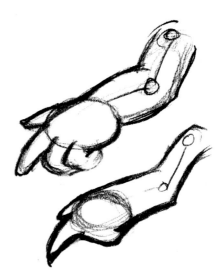

DRAGON HANDS

Sometimes you want hands to be realistic, even if the animal itself is imaginary. This dragon's "hand" was based on my own. Note how the two hands have many similarities: they have similar finger joints and thumb placement. Note how the dragon's claws grow from the same location as the human's fingernails.

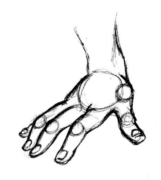
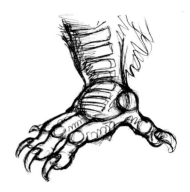

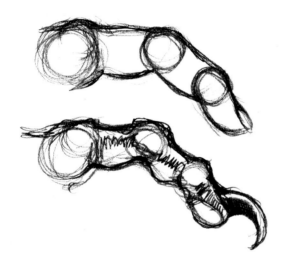

CLAWS

A human finger can morph into a dragon claw. Here, note that I used similar joints and nail/claw placement but exaggerated the dragon's features. You can use the feet of real people or animals as a starting point and then exaggerate them to create a fantastical creature of your own.

PAWS

A very simple foot or paw also makes use of simple shapes as building blocks.

Here's a slightly more complex paw. I started by drawing a half-circle on top and a very slightly curved line on the bottom. Then I added toes and part of the leg. I left a slight indentation behind the foot to suggest the bulge of the leg joint above it and the thickness of the paw below it. The smaller drawing above the foot on the right is the same foot, minus the extra indentation.

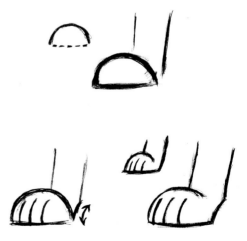

BIRDS

Many birds can be found in manga and anime, ranging from the magnificent Red Bird to the humble sparrow. The bird's body is generally light, with a prominent breastbone and an often surprisingly long neck concealed under a coat of feathers. Birds can fluff out their feathers to keep warm or lay them flat to stay cool, changing their appearance from round and puffed-out to sleek and slim. In addition to bird species, manga fantasy stories sometimes feature people or normally wingless animals who have a pair of wings.

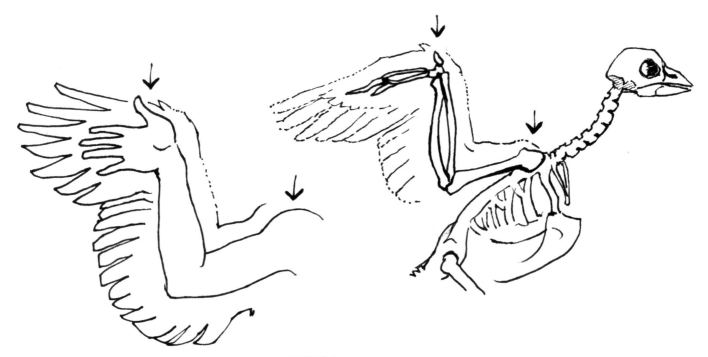

WINGS

The bird's wing can be compared with a human arm. In this comparison, the arrows point to the "shoulder" and the "thumb" on each arm. Note the similarities of structure—wings resemble human arms with very narrow and elongated hands.

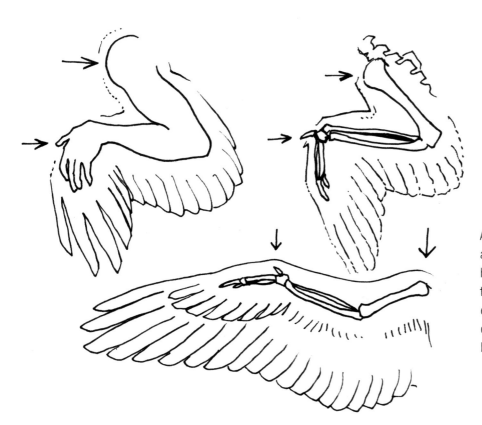

Another comparison of human arms and bird wings is shown here. The arrows point to the shoulders and thumb equivalents on both. The bottom drawing shows some of the basic structure of the feathers.

This pair of "wings" is all style and no substance—it has no real hint of anatomy or bone structure. That may be OK if you just want a pretty design. However, if you wish to draw wings that look like they could actually fly and support the weight of the creature they're attached to, be sure to indicate the basic structure underneath all the feathers. These feathers were made to look soft and light by the use of a stippling technique, which uses dots instead of lines.

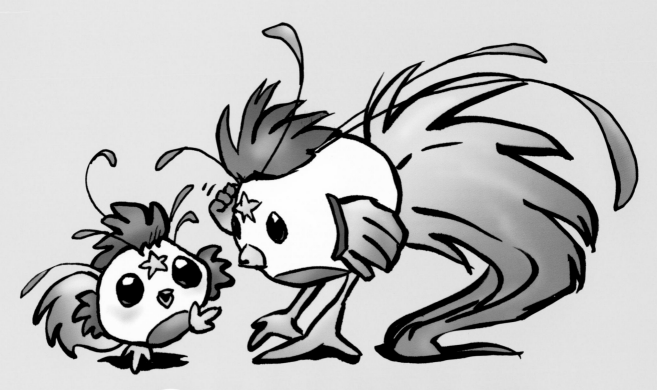

chapter 4

CHIBIS

Chibis, or super-deformed characters, are distinctive big-headed, chubby-bodied beings found in many manga and anime series. They may be used as comedic, extra-cute versions of normal-looking characters, or they may exist in their own right. Normal characters in manga can usually switch between their chibi and ordinary versions at will. Chibis are used primarily to add an extra punch of comedy and cuteness at a funny moment. All but the most serious mangas tend to use chibis on occasion, and some use them almost all the time. No matter how cute a character already is, it can be further "chibified" to an even higher level of cuteness! The key to drawing chibis is to keep them simple. They have an oversized head and a very small, chunky body in proportion to it. Their arms and legs are rudimentary, as are any clothes they may wear. Chibis may be small, but they have plenty of attitude and energy, which is one of the things that make them so appealing.

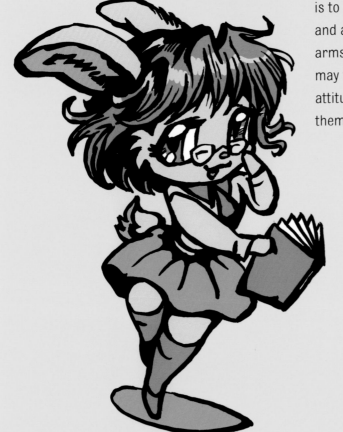

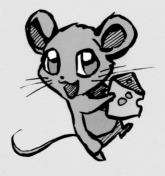

CHIBI PROPORTIONS

In manga, most normal characters are at least three head lengths in height (a realistically drawn human figure is about seven-and-a-half head lengths high). Human-like chibis tend to be about two head lengths in height. (A four-legged animal chibi is also about two head lengths long, or half head and half body.) This norm can vary but is a good rule of thumb. A chibi's hands and feet can also vary in size: Some artists draw them with comparatively large hands and feet, but more often, these are shown as miniature or even nonexistent.

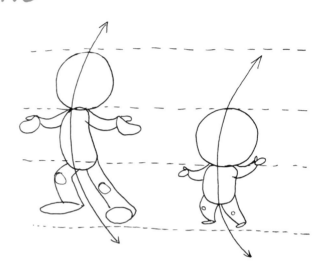

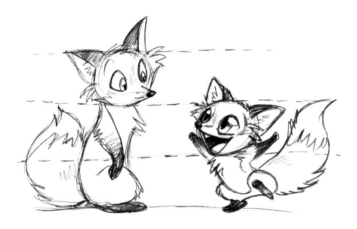

BIG HEADS

These two foxes have about the same size head, but the chibi fox is only one extra head length in height. Tails and human hair usually remain roughly the same size as well, which means in this example that the tail looks much larger in proportion to the chibi fox's smaller body. The ears remain about the same size as well. Note the very basic rendering of the feet.

SIMPLE BODIES

Chibi bodies can be extremely simple, such as this panda bear, which is just an oval body on tubes for legs. Note the wide head and huge eyes.

50

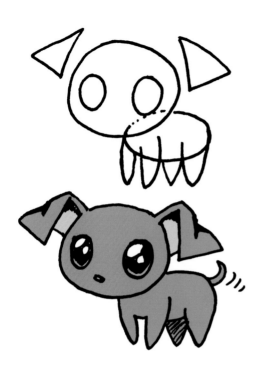

SIMPLE PUPPY

Normally, a four-footed animal's hind legs are more complicated, with a thicker thigh and a heel or hock joint that juts out toward the back. To indicate this without actually drawing it (to keep it simple, in other words), I merely drew the hind legs slightly thicker than the front legs to give them more of a sense of weight.

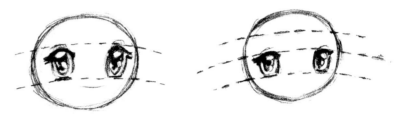

HUGE EYES

Chibis have huge eyes, as shown in these two examples. The one on the left has eyes that take up the middle third of its head. The one on the right has a head divided into quarters, with the top of the eyes starting midway and going down a quarter-head length.

CHIBI MOVEMENT

When drawing chibi bodies, it can help to keep the idea of a flour sack in mind. This is a standard animator's reference tool. Imagine the simplified body of a chibi as a sack of flour, whether two-legged or four-legged. The little pointy ends of the sack correlate with the hands and feet of the creature.

CONVEY ENERGY AND EMOTION

Now add a big head to one end of that flour sack. In conveying emotion and energy, the trick is to keep the sense of movement simple and forceful. Note how arched lines are repeated throughout the drawing to convey the bowed, weary posture of this exasperated creature. Even its ears droop.

This happy bat displays a strong sense of upward and outward movement to convey its excitement. The flour sack on the far right mimics the thrust of the bat's movement. The middle drawing shows the flow of the illustration and how the majority of lines in the drawing continue that upward thrust. The form is kept very simple—anything that isn't a required detail or something that echoes the upward movement of the figure has been left out.

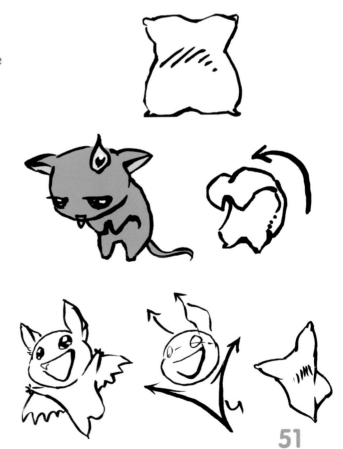

KEYS TO CHIBIFYING A FIGURE

When taking a complicated figure and simplifying it down to chibi form, it is important to simplify as much as possible. Make your drawing as clear and easy to understand as you can by using a minimum of lines.

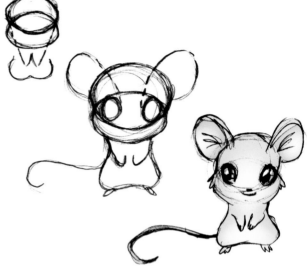

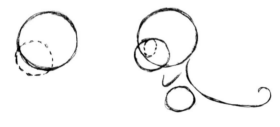

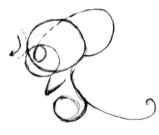

Some animals, for example, lend themselves easily to a chibi form. With their large heads, round bodies, and generous eyes, real mice are practically chibis already, even without the exaggeration. Chibifying them just makes them even cuter!

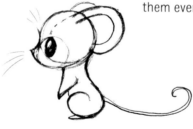

CHIBI MOUSE, SIDE VIEW
A few simple shapes help form the body of this chibi mouse.

This bored cat girl sports distinctive earrings, which are enlarged for emphasis in her chibi form. Note how the lines have been streamlined, and complicated patterns like those in her shoes are merely hinted at.

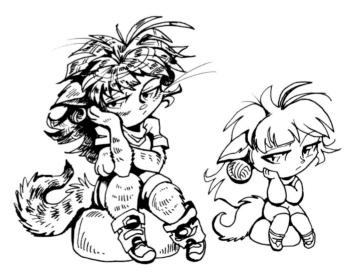

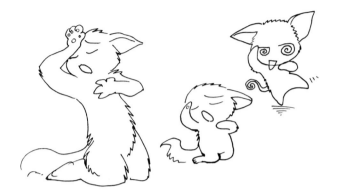

CONVEYING EMOTION

To get the feel for this melodramatic feline in chibi form, I echoed its arm shapes while omitting much anatomical detail. The body of a chibi is small, so there's not much to help convey action and emotion to a viewer. Thus, the body has to be drawn in a straightforward, clear, and "readable" way in order for the viewer to understand it. If you find that the chibi form doesn't express the exact emotion you want once you've simplified it, you can always modify it until you get an image that conveys the emotion you want. I drew this melodramatic, comically "injured" cat as a chibi again (on middle left), but this time in an even simpler and clearer form. The body is facing the viewer, and each of the legs and their positions are easy to "read." The sense of the cat tilting to one side on the far left adds to its off-balance, "stricken" feel.

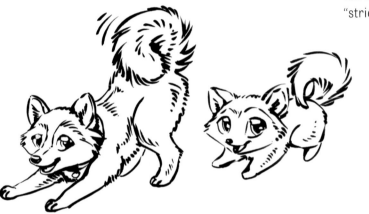

This dog's chibi form has a huge head and eyes and a basic body. I kept the tail big and poofy.

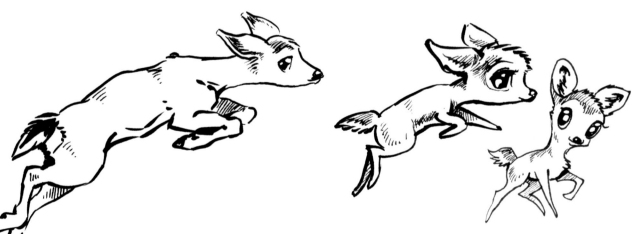

Deer and other thin, long-legged, long-necked animals must retain some of their characteristic shape, even in chibi form. Otherwise, they might not be recognizable as the species they are. Part of drawing chibis correctly involves making judgments about which features on an animal can be left out in the name of simplicity.

MORE CHIBIS

You can "chibify" anything, including mythological animals or animals wearing clothes. When drawing chibi clothes, remember to keep the clothing simple. Draw in just enough detail to let the viewer know what kind of clothes are being worn. Anything more and the chibi drawing may become too "busy" and complicated.

Here is a chibi dragon, chibified yet again. Note the extremely simple legs.

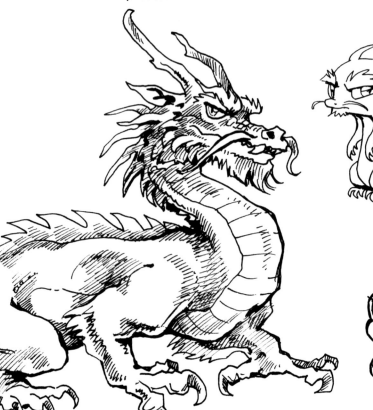

This dragon wasn't easy to chibify, but it could be done! Key features to keep were the eyebrows, horns on the head, indication of claws on the feet, and the intense look of the eyes.

You can give your characters props to hold, like a book or some cheese, which can hint at their personality.

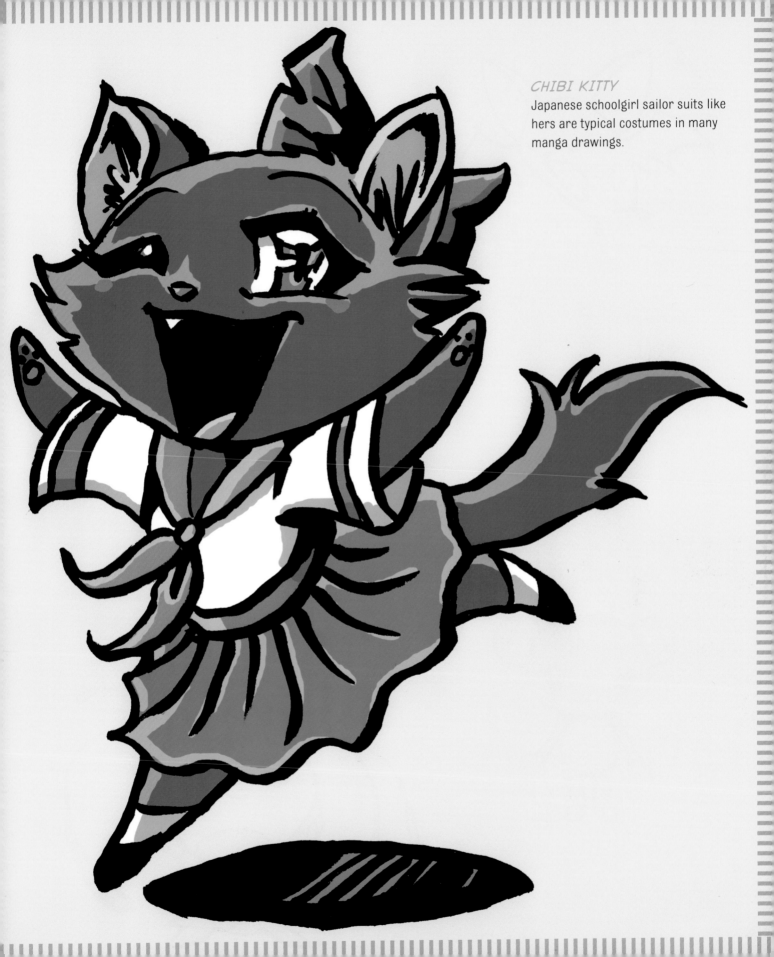

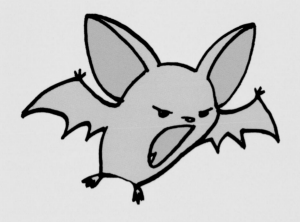

MASCOTS

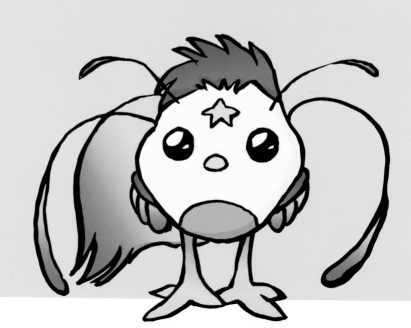

Many manga series have a lovable animal mascot character to round out an otherwise all-human cast. These mascots may be important to the storyline, appearing as a constant companion to the hero or heroine and providing someone for them to talk to (or argue with). They may serve as narrators or observers as the story runs its course. Or, they may just pop up occasionally for a visual "accent" or for comic relief. In these sorts of situations, the human characters are often drawn in a more complex, detailed manner, while the mascot is kept very stylized and cute. In fact, the mascot may consist simply of a round ball with eyes and perhaps one or two other features. Realism is not crucial. Although mascots and chibis look very similar, the chibi form of a character usually reverts back to its more normally proportioned self and a mascot almost always remains in dwarf form. (However, some of these mascots can, when the time is right, change into another, often more impressive, form.) Mascots may be based on real animals, or they may combine likenesses of critters or objects, mixed with the artist's imagination.

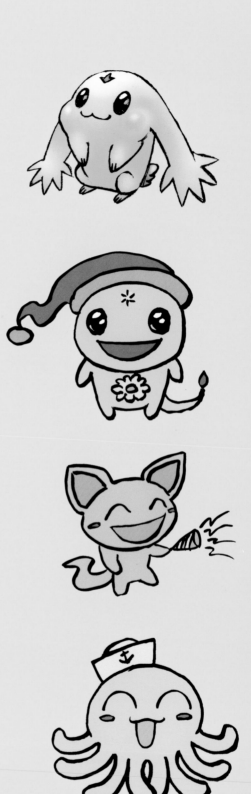

MASCOT BODY FEATURES

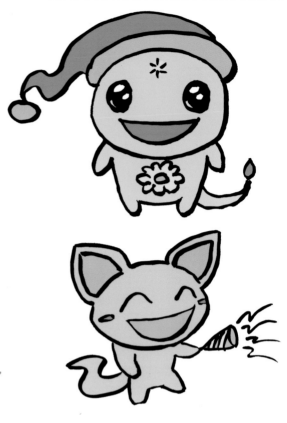

Most mascot characters have a large head and a miniature torso and legs. They usually have several identifying features, either physical ones or special clothing and props that help distinguish them. Some manga mascots have a decorative symbol or "gem" on their foreheads, adding to their distinctiveness. Let your imagination run wild with these guys!

STEP-BY-STEP MASCOT

Manga mascots may feature a pudgy body like this creature's, complete with chubby cheeks, which add to their cuteness. You can add extra features like clothing or jewels to further distinguish a character.

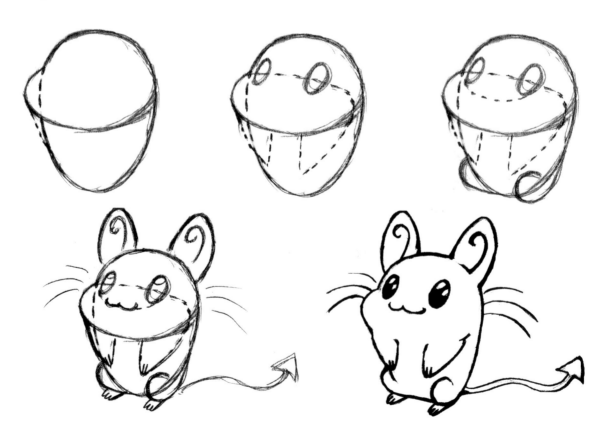

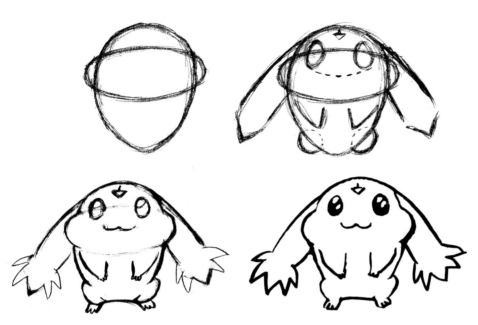

PUDGY CREATURE

I drew the basic body shape (broader at the top) and indicated the creature's chubby cheeks. After that, I added basic anatomy: eyes, legs, long ears, and the location of the arrow-shaped jewel on its forehead. Once I had those in place, I added more details (like toes and fur) and erased or refined my lines, resulting in the final image.

Here is the same pudgy creature (as above) seen from a three-quarter view. This same, basic shape can be used with different facial or body features to create all kinds of appealing monsters.

This bat is shaped similarly to the pudgy creature. He also has a large head and a basic body shape that is broader toward the top than the bottom. His cheeks are not as round, however.

KEYS TO SIMPLIFYING

Think in basic shapes like circles, ovals, and hearts to come up with ideas for mascots. Remember to use as few lines as possible when you draw most of these characters.

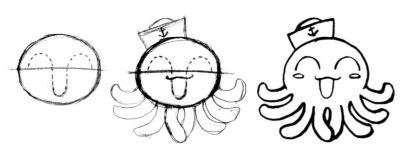

A basic circle-shaped critter is the octopus. Note the two circles implying rosy cheeks. You can add all kinds of extra little features (forehead gems, rosy cheeks, a hat, etc.) to a simple circle shape, and voilà—instant manga mascot!

Manga mascots can be simply sketched, like this little guy. He's equipped with eyes, mouth, and it just so happens, is in the shape of a musical note!

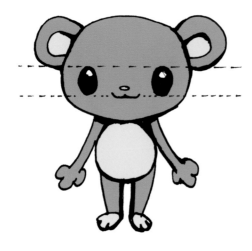

More simple critters are shown here. They often have large eyes, but not always. Notice that their mouths, beaks, or noses are placed in between or just below their wide-set eyes.

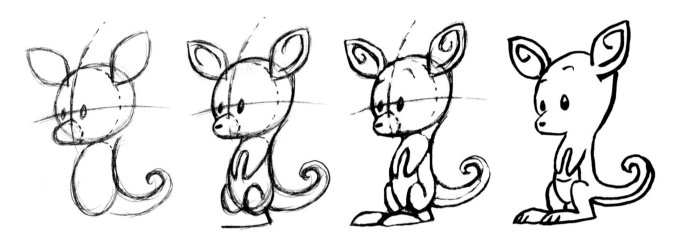

This kangaroo is a little more complicated than some of the other critters but is kept relatively stylized. Swirly designs on her ears add to her whimsical look.

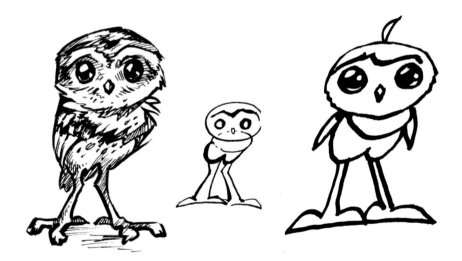

When looking at an animal you want to simplify for a mascot drawing, focus on key shapes and patterns in that animal's body and try to scale them down to their essence (circles, ovals, diamonds, etc.). You can add fine details (like the feather on top of this owl's head) for a cuter look.

THE WORLD OF MASCOTS

Anything goes in the world of mascots. Realism usually gives way to imagination, whimsy or just something that simply looks cool standing next to the other characters in a story.

ANYTHING GOES
You don't always have to base your mascot drawing on a real animal. Realism is not of paramount importance. You can invent something (like the musical note creature earlier) or combine animals. This creature is a sort of weasel-rabbit with a little bird thrown in. Also, mascots often float or fly around with little physical support—it's just their nature!

Lack of realism also applies to the way mascots (and chibis) can hold objects. This candy cane appears to sit in this mascot's paw with no visible means of support, but with these super-cute and simple creatures, it's believable.

MASCOT CLOTHING
Mascots are often distinguished by an article of clothing, such as a hat, scarf, or collar. The identifying attire worn by a mascot may also hint at the manga genre the mascot inhabits. This witchy bat might be found in a manga story set in a spooky place, like a haunted house or graveyard.

SILLY MONKEY

This guy might be found in a manga story located in an exotic setting, or perhaps in a very stuffy and serious setting that needs some shaking up. Even if the main characters are rather serious, the monkey mascot might be used to add humor and whimsy. If the main character is something of a rascal, the monkey might also reflect what is truly that character's heart—even if it is unspoken.

SPACE CHICKEN

He comes from a magical fantasy setting, so the star-shaped gem on his forehead and his brightly colored wings, crest, and tail fit that genre. Note the long feathers that dangle from his body. These can function as arms, giving him the ability to grasp objects, express his emotions, and carry out actions.

SIMPLY CUTE, AND CUTE WITH AN EDGE

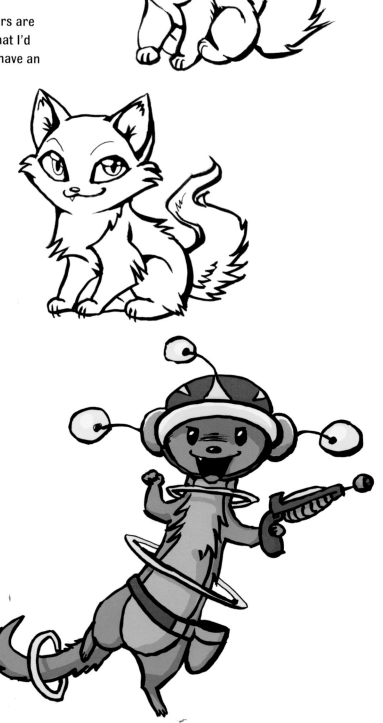

Many manga animal mascots and other characters are sweet and adorable, but some display the trait that I'd call "cute with an edge." They are cute, but they have an extra amount of "attitude" or mischievousness.

CUTE WITH AN EDGE

Note how the kitten at the top of the page looks very soft, fluffy, and innocent with her round eyes and sweet smile. Her body consists of curvier, softer-looking shapes and fur. The kitten below her, by contrast, is cute but has a saucier, edgier look. I gave her a sharper expression, complete with a smirk. I also used more jagged lines to indicate her fur, gave her tail a twistier shape, and endowed her with noticeable teeth and claws. As you can see, she's the more sassy of the two felines.

Speaking of attitude, Space Weasel has plenty of it! His form looks deceptively plain, but has complexity to it once you start drawing him. I began this drawing by blocking in Space Weasel's basic head, body, and helmet shapes. I followed this step by placing his arms, legs, and feet, and then details of his clothing, rings, and his gun. I drew a light line across his face, using it to place his eyes and the antennae on either side of his helmet. I refined the details of his arms, legs, face, and other areas, and then erased and finalized them until the drawing was complete. Space Weasel's outfit gives him a space-age, edgy, video game–like feel. And just how do those rings stay propped up like that? I don't know, but this is one of those situations where anything goes!

Note how the bottom highlights in this squirrel's eyes are not bordered by any lines—this is a stylistic choice. This basic body shape can also be used for inventing other cute animals. Try drawing this creature as something else—perhaps a bunny holding a carrot—but be sure to give him longer ears and bigger feet!

SIMPLY CUTE
A cute pig. Its sweet and innocent look is aided by its big, sparkly-looking eyes.

A winsome cardinal. Note how its basic body shape consists of a "figure eight."

NOW, PLEASE ENJOY THIS SPECIAL SECTION! HERE ARE SPACE CHICKEN AND SPACE WEASEL DRESSED UP AS VARIOUS CREATURES FOUND IN THIS BOOK!

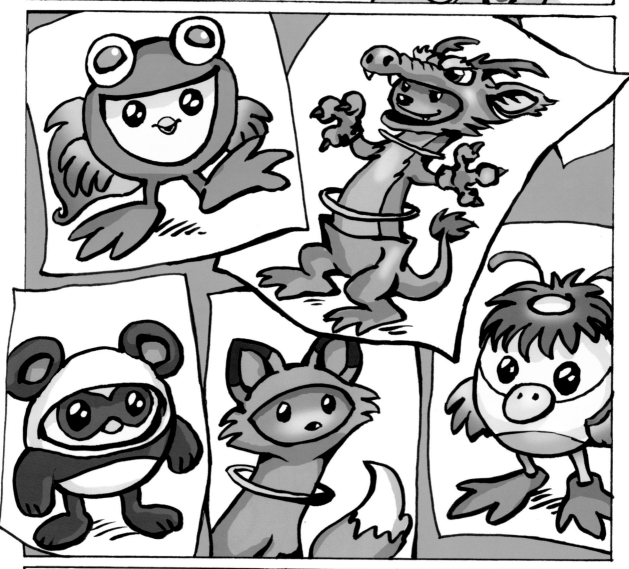

MYTHOLOGICAL AND REAL CREATURES

MYTHOLOGICAL AND SUPERNATURAL MANGA CREATURES

In the following two chapters, you will find a reference section on mythological creatures and real animals in Japanese culture and legend. These chapters are meant to guide you toward a greater understanding of the animals that populate many manga and anime series. The names of the animals are given in both Japanese and English. Commonly shared stories and legends have a way of seeping into the everyday life and language of a given culture. Therefore, knowledge of Japanese tales and culture can increase one's understanding and enjoyment of anime and manga series. It can also provide a starting point for creative ideas and manga-style stories of your own.

Mythological creatures hold much power over the human imagination. These creatures often symbolize valued human traits such as wisdom, ferocity, and loyalty. They also may represent forces at work that would overwhelm any one human being, like a raging ocean storm. They are mysterious and awe-inspiring, and to see any one of them is a rare and memorable experience .

JAPANESE NAME: RYU

ENGLISH NAME: DRAGON

Called *ryu* in Japan, the dragon is a mythical beast celebrated for its power and magic. Unlike European dragons, which are often considered evil, Asian dragons are usually regarded as powerful but benevolent and just. Japanese dragons are said to control the source of rain and thunder, and they can determine the success of a fisherman's catch. They are often depicted in water or among clouds, and are associated with the heavens. The larger a body of water the dragon dwells in, the greater its potency. The sea dragons are among the most powerful of all, and include the Dragon King, or *Ryūjin* (in Shinto religion, he is the god of the sea). Ryūjin lives in a palace at the bottom of the sea and possesses magical "tide jewels" that control the ebb and flow of the ocean. Sea turtles are his preferred messengers. Some dragons, including Ryūjin, can morph into human form.

Most often, Japanese dragons are depicted with a long, wingless body complete with scales, horns on their head, bushy eyebrows, a slightly human-shaped pug nose, and long whiskers or spikes on their face and jaws. Spikes, hair, or flames flow from their back and legs. Their feet are usually three-toed, as opposed to the Chinese dragon, which is four-toed (or, if it is a Chinese imperial dragon, five-toed). Chinese mythology has heavily influenced Japanese dragon lore. One example is the legend of the four guardians of the Chinese constellations. The Azure Dragon represents the direction of East, the season of spring, and the element of wood. The other symbols are the Red Bird or "phoenix," which represents the South, summer, and fire, respectively. The White Tiger represents the West, autumn, and metal, and the black tortoise the North, water, and winter. The dragon is sometimes paired with the Red Bird, either engaged in mortal combat or depicted as a male (dragon) and female (Red Bird) in marital harmony.

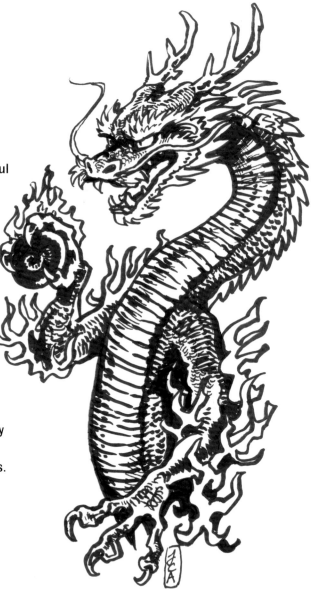

A Japanese dragon holds a jewel of power in its claws.

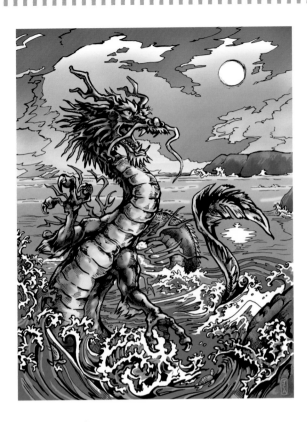

For detailed instructions on how to create this Sea Dragon King, see pages 124–135.

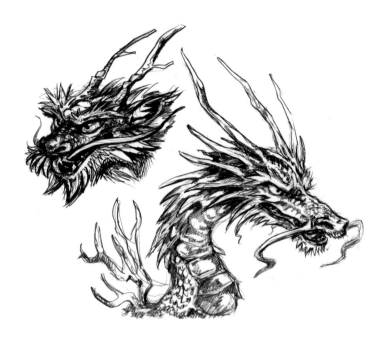

Japanese dragons usually have three toes.

Japanese dragons vary in appearance—from more stout and hairy-looking creatures with short muzzles and broad pug noses to the more elongated and elegant examples. Asian dragons possess myriad horns, spikes, whiskers, and other appendages sprouting from their heads.

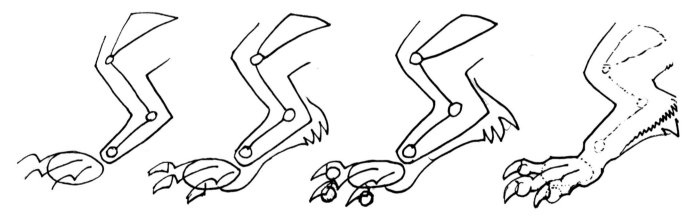

Drawing a dragon foot in four steps.

JAPANESE NAME: KIRIN

ENGLISH NAME: ASIAN UNICORN

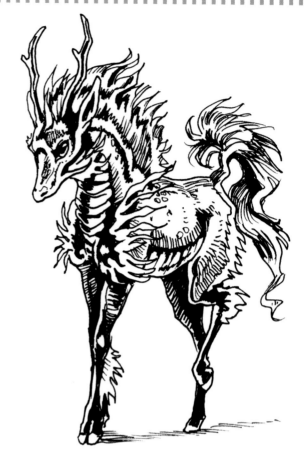

Kirin are immensely powerful, chimerical creatures which, despite their fierce look, are symbols of goodness, gentleness, and purity. They can vary in appearance but generally have the body of a deer (especially in Japan), the tail of a horse or ox, the head of a dragon, deer, or lion, and scales like a fish. They are considered by some to be Asian unicorns and are sometimes referred to as mythical giraffes. Part of their body is also fringed with wavy hair in the guise of fire. Kirin may have one horn on its head, like a unicorn, or two. No matter what form it takes, the kirin can almost always be identified by its hooves.

A more deer-like or unicorn-like kirin.

Kirin are said to appear only in a land governed by a just and fair ruler, and often do so at the birth or death of a great and wise person. Kirin are considered good omens and are associated with prosperity, peace, and good luck. They are said to be excellent judges of character. The kirin is careful not to trample any living thing, and it can walk on water. When the kirin's anger is aroused by the actions of a sinful person, it can muster great power to punish him or her, including spouting fire from its mouth or spearing the sinner through the heart with its horn. It may live for a thousand or more years. Some consider the Japanese kirin to be even more powerful than the dragon or Red Bird.

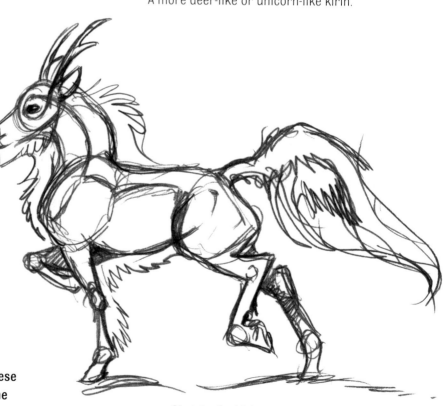

Sketch of a kirin.

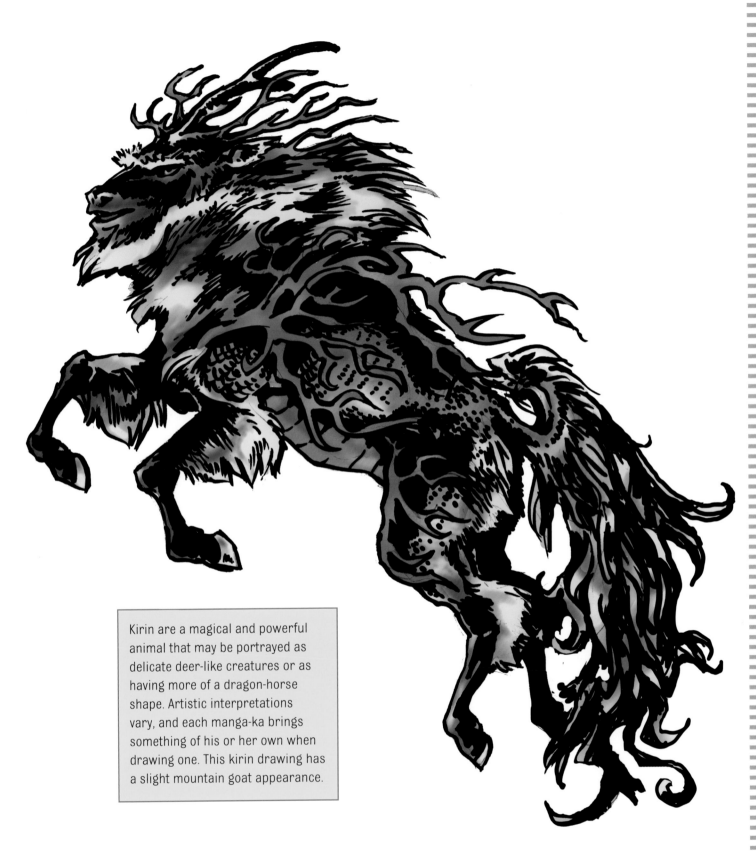

Kirin are a magical and powerful animal that may be portrayed as delicate deer-like creatures or as having more of a dragon-horse shape. Artistic interpretations vary, and each manga-ka brings something of his or her own when drawing one. This kirin drawing has a slight mountain goat appearance.

73

JAPANESE NAME: KOMA INU

ENGLISH NAME: FU DOG

The fu dog, also known as a *shishi* (lion) or *koma inu*, is a mythological animal based on a lion. It guards temples and other important places, scaring away evil spirits. Shishi is a mythical lion from Chinese legend and popular in Japanese tradition, especially in the New Year's lion dance.

Fu dogs are muscular, broad-muzzled creatures with a mane, a flowing tail, and rarely, a single horn on their head. Their ears are relatively small and may be floppy like a dog's or erect like a lion's. The idea of guardian lions was transmitted from India to China and Korea, where people had never seen a lion before, and so they picked up several dog-like traits in the process. The ever-more stylized animals were then brought into Japanese culture.

Fu dogs are often found in pairs: one with its mouth open and the other with its mouth closed. One explanation is that in Japan, the open-mouthed animal designates a lion and the closed mouth creature a lion-dog, though more recently, both have been considered lion-dogs. Another, more common interpretation is that the open-mouth fu dog is exhaling its breath, making an "ah" sound, while the closed-mouth animal is inhaling, making an "m" sound. This is the sound of the sacred "om," which is said to represent the universe in Hinduism, both the beginning and the end.

Fu dogs are known to be fierce and loyal guardians. They also display a playful nature and are very protective of children. Many times the male fu dog can be seen in a pose with his paw on a globe or ball while the female gently places her paw on a cub. However, according to one legend, they will throw their cubs off a cliff to test their strength!

This fu dog was drawn with attention to detail and anatomy in order to convey a sense of its power.

OPPOSITE PAGE: A fu dog plays with her cub. Many statues of fu dogs depict the female in a similar pose.

This fu dog is more humorous and simply drawn than the previous one. He just wants to play fetch.

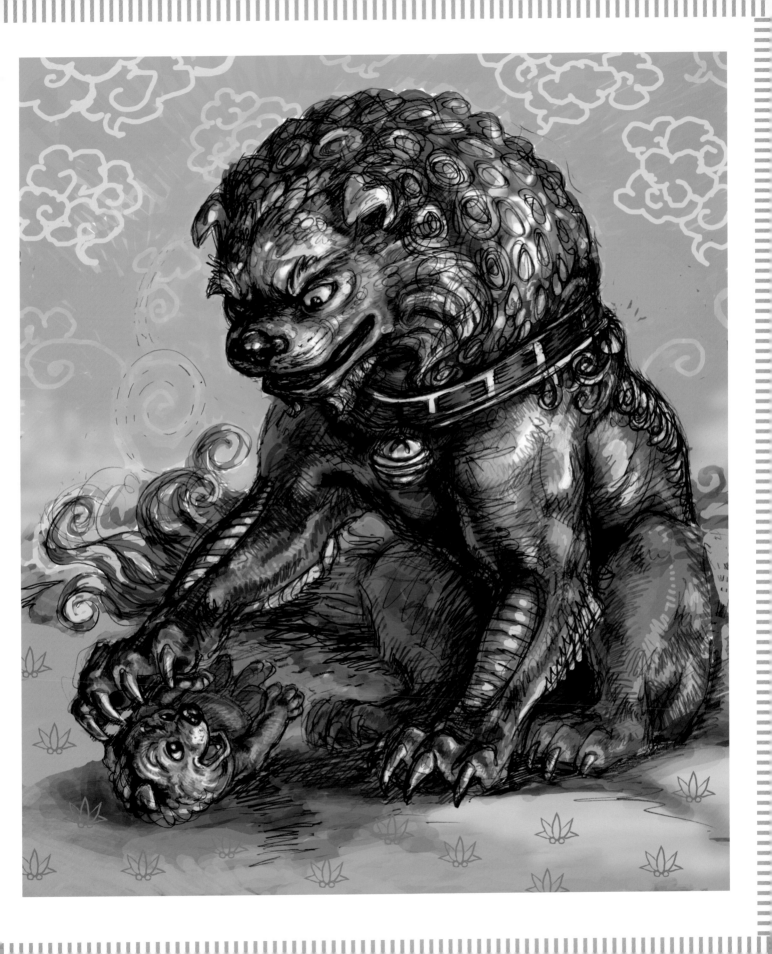

JAPANESE NAME: BAKE-NEKO

ENGLISH NAME: MONSTER CAT

A house cat can transmogrify into a monstrous *bake-neko* when it has lived from three to thirteen years, reached a certain weight, or been allowed to grow a long tail. These *yokai* (supernatural spirits or demons found in Japanese folklore) are usually evil-natured. They may sometimes take a human guise, killing their master and then taking their form. They haunt households, hunt humans, can create fireballs, walk on their hind legs, and may reach a length of five feet.

BAKE-NEKO
A bake-neko will disguise itself as a human. Here one slips into a kimono, which is a traditional Japanese dress or robe.

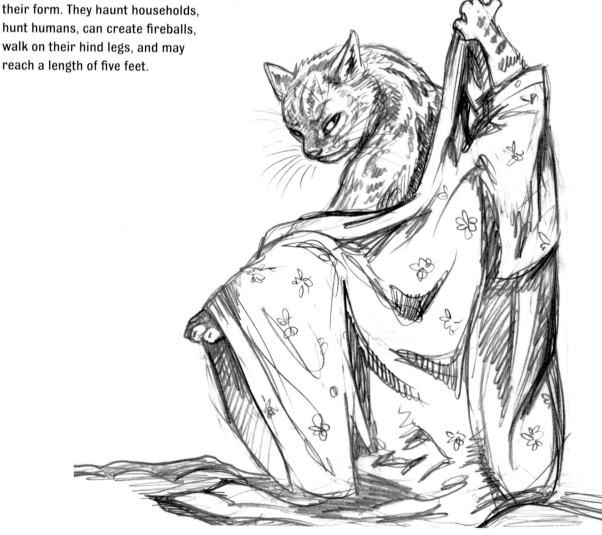

JAPANESE NAME: NEKO-MATA

ENGLISH NAME: FORKED-TAIL CAT

At some point, a bake-neko's tail may fork in two, then it becomes the dreaded two-tailed *neko-mata* an even more powerful monster cat. Neko-mata are said to be able to reanimate corpses by jumping over a dead body!

NEKO-MATA
Neko-mata have forked tails and immense powers.

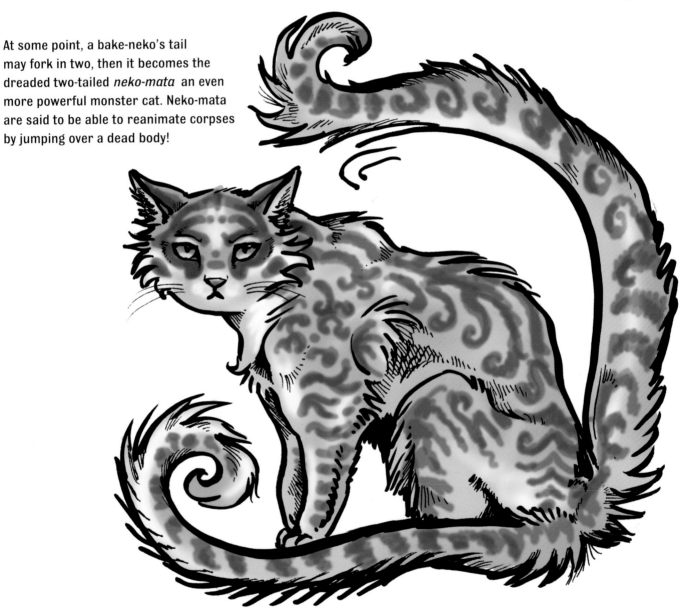

JAPANESE NAME: KAPPA
ENGLISH NAME: RIVER SPRITE

Kappa inhabit the waterways of Japan. These water imps or river sprites are about the size of children and are usually said to have a turtle-like shell, scaly skin, and webbed feet. Their heads may be either ape-like or beaked like a turtle or bird. They are agile swimmers and awkward on land. Their most striking feature is a shallow, water-filled depression on top of their heads, surrounded by bushy hair. Kappa derive their strength from this reservoir: If they are tricked into bowing or otherwise spilling the water in it, they become weakened or even die.

Kappa are mischievous by nature, and their antics may range from harmless pranks (like loudly passing gas) to more serious offenses, such as trying to drown people and horses. Travelers must be wary around water because the kappa sometimes like to feed on human intestines. However, kappa are not always the enemies of humans, who can ask for their protection against water accidents or to help with farm work. Kappa maintain a firm sense of etiquette and will always keep their word. Children are encouraged to follow the custom of courteously bowing to them because the kappa cannot help but bow in return (and thus fatally empty the reserve of water on its head).

Kappa can understand and speak Japanese and may challenge people to games or tests of strength such as sumo wrestling. They also are extremely fond of cucumbers—in fact, a type of cucumber sushi roll (kappa-maki) is even named after them. Kappa that try to harm humans and are caught will agree to cease their wicked ways and offer gifts in return for their freedom. Gifts may include fresh fish deposited at the family's doorstep every day, or a share of some of the kappa's vast medical knowledge.

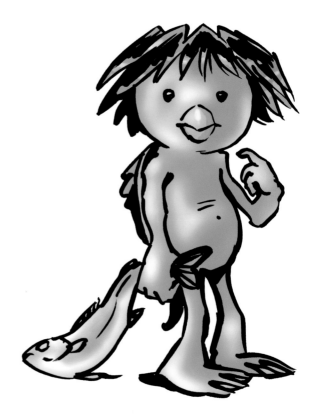

Kappa with a fish.

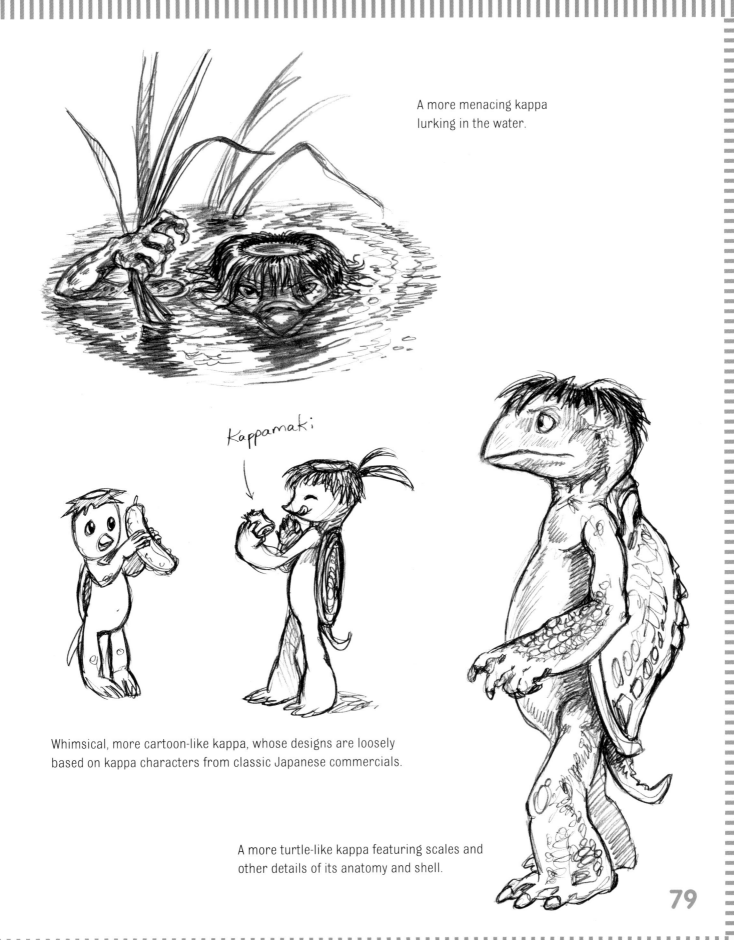

A more menacing kappa lurking in the water.

Kappamaki

Whimsical, more cartoon-like kappa, whose designs are loosely based on kappa characters from classic Japanese commercials.

A more turtle-like kappa featuring scales and other details of its anatomy and shell.

JAPANESE NAME: TENGU

ENGLISH NAME: HEAVENLY DOG

Tengu get their name from the Chinese *t'ien-kou*, a celestial dog believed to have been inspired by real-life comets that landed in ancient China. The t'ien-kou is said to swallow the sun during eclipses. However, in Japan, the tengu is bird-like. Tengu are another species of *yokai* (supernatural spirits or demons found in Japanese folklore) that live in the mountains of Japan and hatch from eggs.

The tengu's appearance can vary, but they are usually depicted as male and possess a combination of avian and human characteristics. Low-ranking tengu often appear more crow-like (*karasu* tengu), while higher-ranking tengu appear more human but with an unusually long nose (*yamabushi* tengu). Yamabushi tengu may have white hair, a red face, and a long nose, and often carry with them a fan made of feathers. Tengu can communicate to humans without moving their mouth and can both fly and teleport to get around. They are often associated with the yamabushi, or mountain priests, who lived in isolation high in the mountains and practiced the old Japanese religion of Shugendo. As a result, tengu are often depicted with a priest's small round, black cap, short robes, and sash with small pom-poms.

Tengu range in character from benevolent to evil. In older times, tengu were often depicted as vengeful spirits who would abduct people and leave them dazed and confused in remote places, possess other people, rob temples, and cause other mischief. They are associated with vanity and pride, and it is

Crow-like karasu tengu.

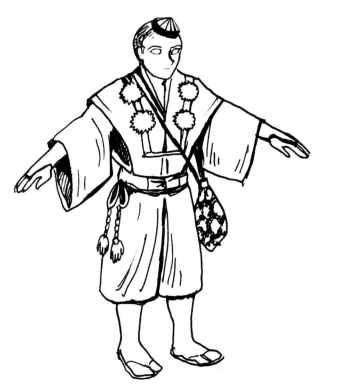

A simplified drawing of a yamabushi priest's outfit. Tengu often wear similar clothing.

said that tengu are the ghosts or reincarnations of arrogant humans. Even so, tengu are said to dislike human braggarts and those who misuse power. Today, they are often depicted as protective, curious, and helpful creatures and as guardians of mountains and sacred places. These tengu are still on the vain and mischievous side, but are basically good-hearted and willing to help humans that are lost or are in need.

Tengu are also known to be skilled in armed combat, and rumor has it that some ninjas received training from the tengu themselves! Tengu live in a social hierarchy, with one great leader (usually a more human-like tengu) ruling over the others. The greatest of these leaders is *Sōjōbō*, the king of the tengu, who is said to live on Mount Kurama, north of Kyoto, Japan. He is an ancient yamabushi (literally, one who hides in the mountains) tengu hermit with white hair and is profoundly powerful and wise. Legend says that he taught the great Japanese warrior Minamoto no Yoshitsune swordsmanship, magic, and other survival skills during the twelfth century.

Finished piece of a yamabushi tengu (left) and karasu tengu (below) practicing their fighting skills.

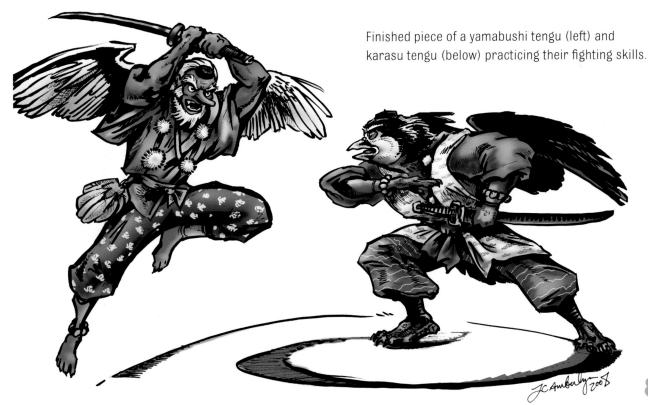

JAPANESE NAME: BAKU

ENGLISH NAME: DREAM-DEVOURING BEING

Baku are mythological creatures that have the power to eat bad dreams. They greatly resemble the large, long-nosed, plant-eating mammal known as a *tapir*. Baku are said to be a chimerical mix of animal species, usually including tapir (or elephant), tiger, and ox. If someone awakens from a bad dream, that person can call upon the baku to eat it, which the baku does willingly. The bad dream is then replaced by good luck.

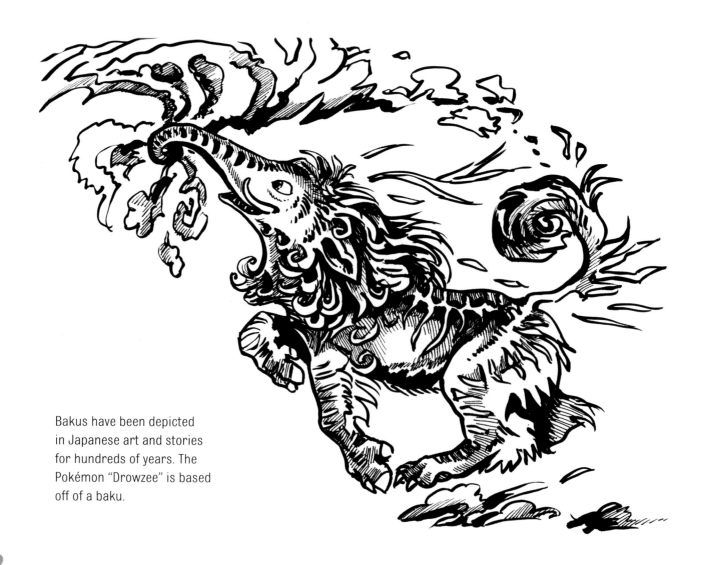

Bakus have been depicted in Japanese art and stories for hundreds of years. The Pokémon "Drowzee" is based off of a baku.

JAPANESE NAME: HOU-OU OR SUZAKU

ENGLISH NAME: RED BIRD

The Red Bird, also known as the phoenix, *Hou-ou*, or *Suzaku*, is a mythological pheasant-like bird that is often depicted together with the dragon. It appears to humans only rarely, usually to mark the dawn of a new era, and symbolizes fire, justice, and peace. The Red Bird is similar to but not quite the same as the phoenix with which most westerners are familiar. The Red Bird is more social than the phoenix, and it does not regenerate itself by burning into ashes as the phoenix does. However, both are considered fire birds.

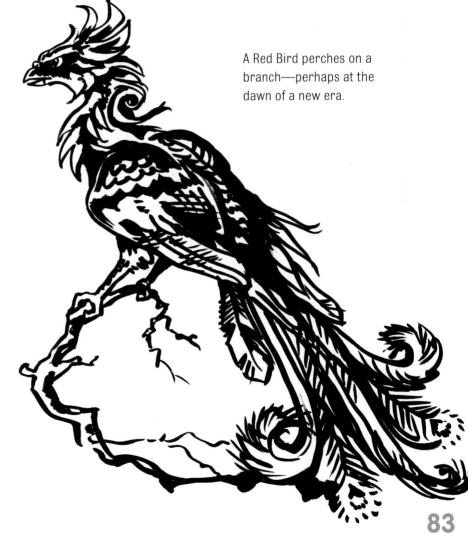

A Red Bird perches on a branch—perhaps at the dawn of a new era.

The Red Bird is also known as the Vermillion Bird. This regal bird has a tail feather for each month of the year (twelve or thirteen depending on the solar or lunar cycle used) and displays five mystical colors: red, yellow, blue, black, and white.

MANGA CREATURES BASED ON REAL ANIMALS

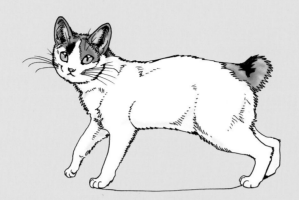

This chapter focuses on real animals found

in Japan and other parts of the world. As people live and interact with various animal species, they create stories about them. Those animals may gain a unique reputation in the human world, often representing an aspect of our own personality, such as greed or mischievousness. Some stories blur the line between the real animal and its mythological counterpart, and at times it can be hard to tell which is which.

This chapter includes some of the sounds that these Japanese animals make. These can be useful to know when creating a drawing or manga-style comic. You can add these sound effects for added vividness or simply as a nice design element. Keep in mind that various cultures apply different sounds to the same animals. For instance, someone who speaks English would tell you that a cat says "Meow" but a Japanese person would say a cat says "Nya."

JAPANESE NAME: KITSUNE

MAKES THE SOUND: "KITSU"

ENGLISH NAME: FOX

Kitsune, or red foxes, are animals native to Japan, but their image is steeped in mythology and folklore. The kitsune of legend are magical, mysterious, and mischievous. They can be good, evil, or somewhere in between, and their wisdom and intelligence grow with age. Kitsune have been known to possess people, invade their dreams, create realistic illusions, breathe fire, or become invisible. Although they always strive to repay their debts, kitsune morality is not the same as ours, so caution should be taken. They grow multiple tails as they age (some say the first tail grows only after the fox has lived one hundred years). A nine-tailed fox is a very powerful and wise creature and is usually white or gold in color.

Kitsune are shape-shifters and often disguise themselves as humans. They may do this to cause mischief, tricking humans to get something they want or to take revenge, or they may morph into human form to be with someone they love. Many stories tell of foxes disguising themselves in human form (usually as beautiful maidens) and even getting married to unsuspecting men. However, the fox's identity is eventually discovered, at which time the fox usually flees. Its true identity may be betrayed by a

BELOW LEFT: A rough thumbnail image that puts down on paper the basic idea and flow of the piece.

BELOW MIDDLE: A more detailed, fleshed-out preliminary drawing that sets the stage for the final inked version.

BELOW RIGHT: The finished inked and computer-colored piece.

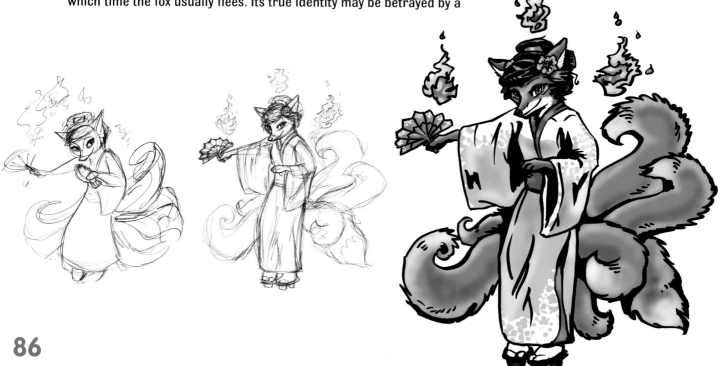

fox-shaped shadow, reflection, or kitsune tail popping out from under its clothes during a moment of carelessness. They also become uncomfortable and agitated in the presence of dogs. Over their heads kitsune place a reed or broad leaf (or sometimes even a skull) to aid in their magical transformations.

Foxes are also associated with Inari, the Japanese god of rice. Rice has traditionally been extremely important to Japanese agriculture and life, and Inari religious shrines are still very common throughout the country. The entrances to these shrines are marked with red double-beamed gateways called *torii* (a common sight in many manga and anime) and are usually accompanied by statues of white foxes, which are Inari's messengers. These foxes, called *myobu*, are guardians and are considered to be in a class of their own, apart from the more common nogitsune or wild fox. (Myobu also refers to a rank of women in the imperial court.) The white foxes, along with nine-tailed foxes and black foxes, are considered good omens. Kitsune (especially the myobu) often carry jewels or balls that may contain the fox's power or be linked to prosperity and wish fulfillment.

The kitsune's favorite food is said to be fried bean curd, called *aburaage*, which is sometimes prepared in a soup-like broth with noodles called *kitsune udon*. Kitsunes can create a ghostly fox-fire (*kitsune-bi*). A legend about foxes and fire concerns a shimmering band of horizontal flames seen out in the distance on a field or riverside at night. This can signify a *kitsune no yomeiri*, or fox wedding. The flickering lights are said to be a procession of lanterns carried by the foxes as they march in a bridal procession. Rain falling on a bright sunny day (a sun shower) can signify the same event.

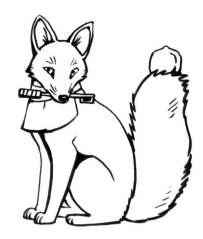

Inari's messenger, a myobu kitsune. It holds a key in its mouth and a ball of power on its tail. Fox statues at Inari shrines often have red "bibs" placed around their necks. In Japan, the color red is associated with the healing of illness.

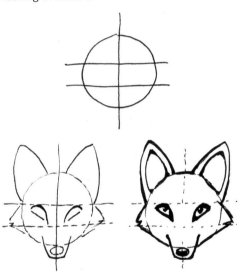

I started this drawing of a fox's head with a circle and a grid. Using the grid as a guide, I placed the eyes, bottom of the ears, and nose, and then added detail and shading.

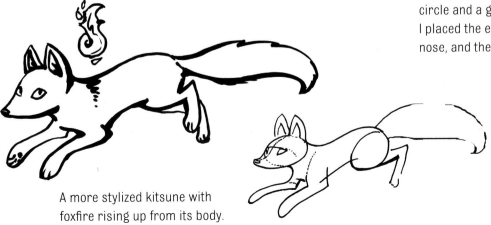

A more stylized kitsune with foxfire rising up from its body.

JAPANESE NAME: TANUKI

MAKES THE SOUND: "PON POKO" (AS IT DRUMS ITS BIG BELLY)

ENGLISH NAME: RACCOON DOG

The *tanuki*, or raccoon dog, is sometimes mistakenly referred to as a badger or raccoon but is actually a member of the dog family. Like the *kitsune* (see page 86), tanuki are real animals native to Japan that have a strong presence in that country's folklore as a shape-shifting, mischievous animal spirit with supernatural powers. They are often shown wearing straw hats and carrying bottles. In Japan, male tanuki are often depicted in an anatomically correct fashion, which can surprise some non-Japanese viewers.

Tanuki can be good or evil, but are perhaps best known for being somewhat comical, gluttonous, and a bit absent-minded. They rarely ever pay their bills, and in fact, they may use their shape-shifting powers to turn leaves into counterfeit money. They also use leaves to help themselves transform into various shapes. While a kitsune often shape-shifts into a human form, a tanuki often transforms itself into an object. One famous story tells of a man who rescues a tanuki caught in a trap. The tanuki repays the man for his kindness, transforming itself into a teapot and telling the man to sell him, which the man does. When the monk who bought the teapot tries to boil water in it, the teapot grows legs and runs away! This story has various endings, ranging from the "teapot" choosing to remain at the monk's temple to its return to the man who rescued him.

A realistic raccoon dog.

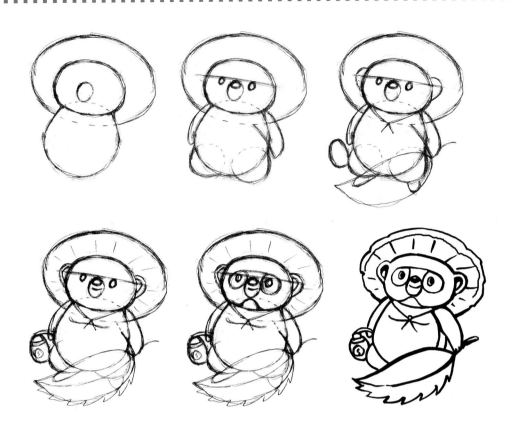

A more cartoon-like tanuki drawn step by step.

Tanuki in color.

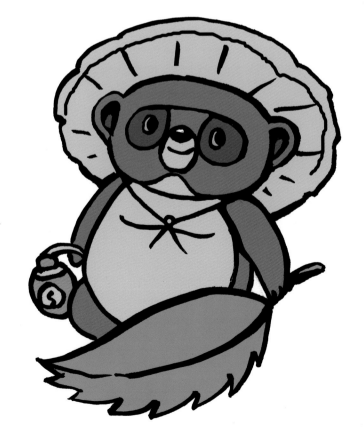

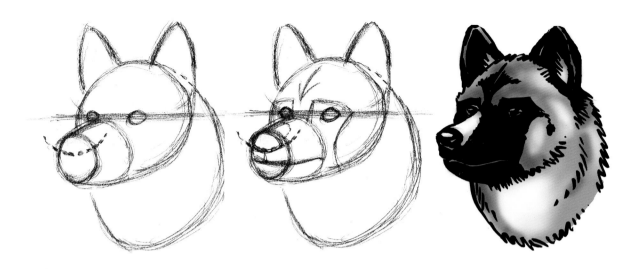

JAPANESE NAME: INU

MAKES SOUND: "WAN WAN" (EQUIVALENT OF "WOOF WOOF")

ENGLISH NAME: DOG

There are six original breeds of Japanese dogs, including the Akita Inu and the Shiba Inu. The Shiba Inu is similar in appearance to the Akita, but much smaller. In addition, several dog breeds with Japanese in their names (such as the Japanese Chin) are not originally Japanese dogs but were brought over to the country and developed. Several species of wild dogs, such as foxes and tanuki, are found in Japan today. At one time, Japan was home to wolves, but they were hunted to extinction.

TOP: To draw an Akita Inu head, I first blocked in the massive shapes of its head, muzzle, and neck and indicated the placement of the eyes and nose. I added a mouth and some shading guidelines to its face. In the last stage, I did the final inking, erasing pencil lines once the ink was dry.

BOTTOM: A realistic drawing of a Shiba Inu, an ancient breed of Japanese dog known to make a high-pitched yodeling sound when excited.

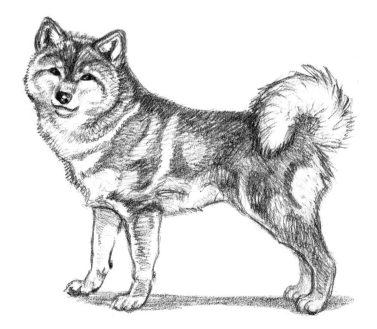

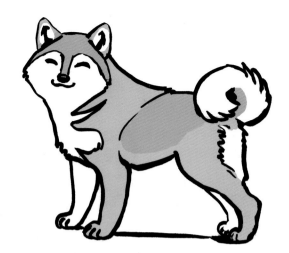

For this more stylized drawing, I emphasized the dog's foxy and white-coated face and his fluffy tail.

More stylized dogs.

You can draw any breed of dog in manga-style—even a poodle! Note this pooch's manga-style eyes, mouth, and highly stylized ears.

JAPANESE NAME: NEKO

ENGLISH NAME: CAT

MAKE THE SOUND: "NYA NYA"

(EQUIVALENT OF "MEOW MEOW")

Cats, like dogs, have a long and storied history in Japanese culture. Whether an ordinary house cat or a supernatural youkai spirit, cats always know how to leave an impression.

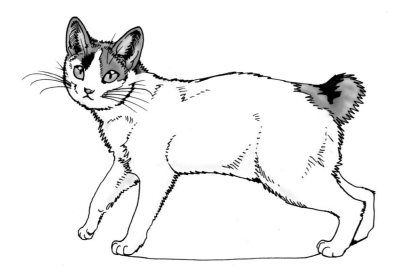

The *Maneki Neko* (welcoming cat) is a good example of the feline's place in Japanese popular culture. Many Japanese shops display a statue of a calico cat with one paw raised in the air, which is the Japanese gesture for "Come here." This cat is believed to bring good luck to its owner. The lucky cat is usually depicted with a collar, bell, and some kind of decorative bib.

The Maneki Neko is usually shown to be a Japanese bobtail—a small, sleek, and friendly cat native to Japan. Japanese bobtails are named, naturally, for their bobbed tails, which resemble those of rabbits. They are active, intelligent cats that tend to be very people-oriented and talkative.

"Cat girls" are a popular subject in anime and manga. With varying degrees of human and cat-like traits, these characters pop up in a variety of stories.

Cute monkey with banana.

JAPANESE NAME: SARU

ENGLISH NAME: MONKEY

MAKES THE SOUND: "UKI UKI"

Japan is home to one monkey species fittingly called Saru or Japanese macaque. They are also called snow monkeys and are known for enjoying a warm bath in Japanese hot springs during the winter. Monkeys are featured in many legends and myths, sometimes as the hero or a protective spirit. They are also known for their mischievousness.

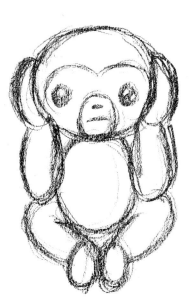
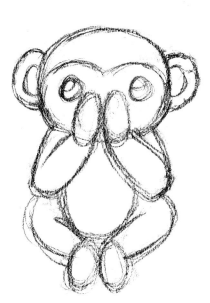

THREE WISE MONKEYS

The Three Wise Monkeys, thought to originate from a seventeenth-century carving at a shrine in Nikko, Japan, embody the concept of "See No Evil, Hear No Evil, Speak No Evil." In Japanese, the saying and its association with monkeys is play on words because the word for monkey sounds similar to the words "Don't see," "Don't hear," and "Don't speak."

JAPANESE AND ENGLISH NAME: PANDA

The panda is a species of bear native to China, but is known and loved worldwide for its cute appearance and distinctive black-and-white mask. Pandas are popular in Japan and fairly common in manga and anime. They can be portrayed as very simple chibi characters or as massive yet powerful hulks.

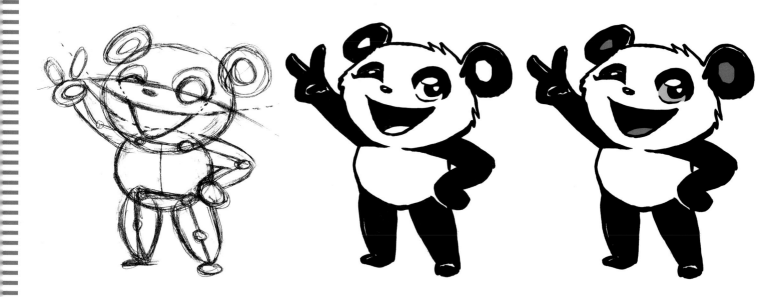

In this rough sketch of an adorable panda, note how the lines and edges of the panda's face, legs, and body flow together. For instance, the line of the lower mouth arcs upward to meet the edge of the panda's eye patches. The rough arc drawn on the head indicates the eyes trail off to meet the top of the outstretched hand. This kind of connectedness adds to a sense of symmetry and harmony in your drawing, which helps create a character that is appealing to the eye.

JAPANESE NAME: UMA

MAKES THE SOUND: "HIHIIN" (EQUIVALENT OF "NEIGH");
THE SOUND OF THE HOOVES IS "PAKA PAKA"
ENGLISH NAME: HORSE

The uma, or horse, has been part of Japanese culture for a long time, perhaps for more than a thousand years. Horses were important and highly prized, valued as draft animals and used as military steeds. Japanese samurai warriors were known for their skill in fighting while riding a horse. In earlier eras, these horseback riders used bows and arrows and later fought mostly with swords. An especially large and heavy sword called a *zanbatō* was once used to strike down both horse and rider. Another enemy of the horse is said to be the legendary kappa, which likes to pull horses into the water to eat them (see discussion on page 78). Today, skilled archers on horseback practice *yabusame*, an archery technique for shooting a stationary target while riding atop a speeding horse.

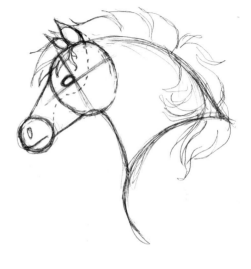

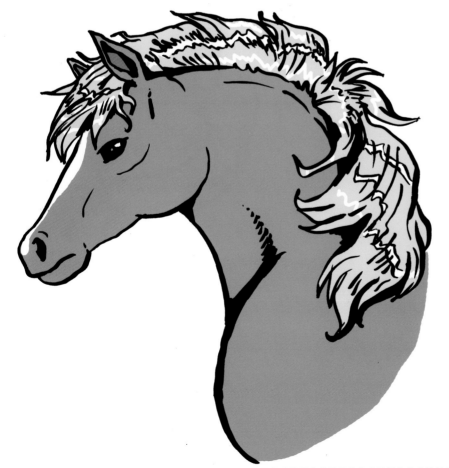

In this drawing of a horse's head, I emphasized its long, flowing hair to create a stylized manga look. The dotted line in the rough sketch indicates some of the underlying bone structure—the protrusion of the skull around the eye socket and how it extends down the nose to the mouth.

JAPANESE NAME: TORI

ENGLISH NAME: BIRD (CHICKS OR SMALL BIRDS)
MAKES THE SOUND: "PIYO PIYO"

JAPANESE NAME: SUZUME
ENGLISH NAME: SPARROW (OR SIMILAR BIRD)
MAKES THE SOUND: "CHUN CHUN"

JAPANESE NAME: TSURU
ENGLISH NAME: CRANE

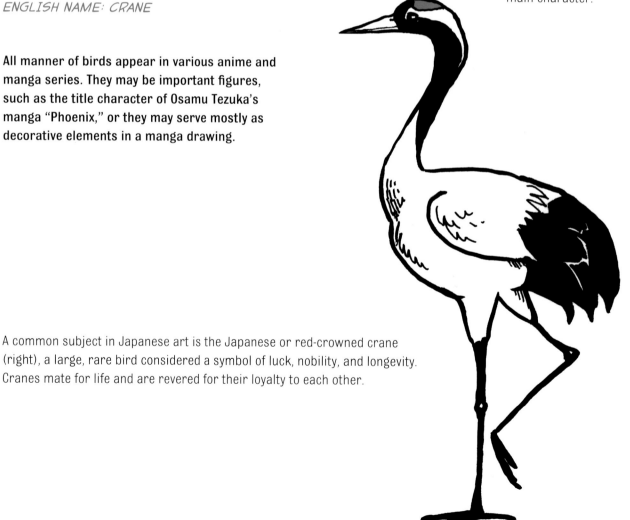

Songbirds and sparrows (see above) appear in manga, often as a decorative touch to a drawing featuring another main character.

All manner of birds appear in various anime and manga series. They may be important figures, such as the title character of Osamu Tezuka's manga "Phoenix," or they may serve mostly as decorative elements in a manga drawing.

A common subject in Japanese art is the Japanese or red-crowned crane (right), a large, rare bird considered a symbol of luck, nobility, and longevity. Cranes mate for life and are revered for their loyalty to each other.

JAPANESE NAME: NIHON KAMOSHIKA

ENGLISH NAME: JAPANESE SEROW

The serow is a kind of goat-antelope native to northern Japan. This thickly furred animal is a vegetarian, feeding on acorns and leaves, and lives on densely forested mountain slopes. The serow is usually solitary or found in small family groups.

A realistic pencil drawing of a Japanese serow.

This is a very cute, cartoon-like serow.

JAPANESE NAME: KAERU

MAKES THE SOUND: "KERO KERO"
(EQUIVALENT OF "RIBBET")
ENGLISH NAME: FROG

In Japan, frogs are considered to be creatures of good luck and fortune. The Japanese word for frog, "kaeru," also means "to return."

This cute, chibi frog has huge eyes that feature two highlights for a sparkly look. You can add pink cheeks for an even more endearing character.

A very simplified, cute crab.

JAPANESE NAME: KANI

ENGLISH NAME: CRAB
MAKES THE SOUND: "CHOKI CHOKI"
WITH ITS CLAWS (A CUTTING SOUND)

Japan consists of islands surrounded by ocean, so crabs and other sea animals are part of people's daily life and sustenance.

JAPANESE NAME: HAMUSUTAA

ENGLISH NAME: HAMSTER

MAKES THE SOUND: "CHUU CHUU"

Hamsters are cute, furry rodents that people all over the world keep as pets. They are one of those animals that lend themselves easily to a chibi form, since they are already little and pudgy.

An angry hamster: Even cute animals have bad days.

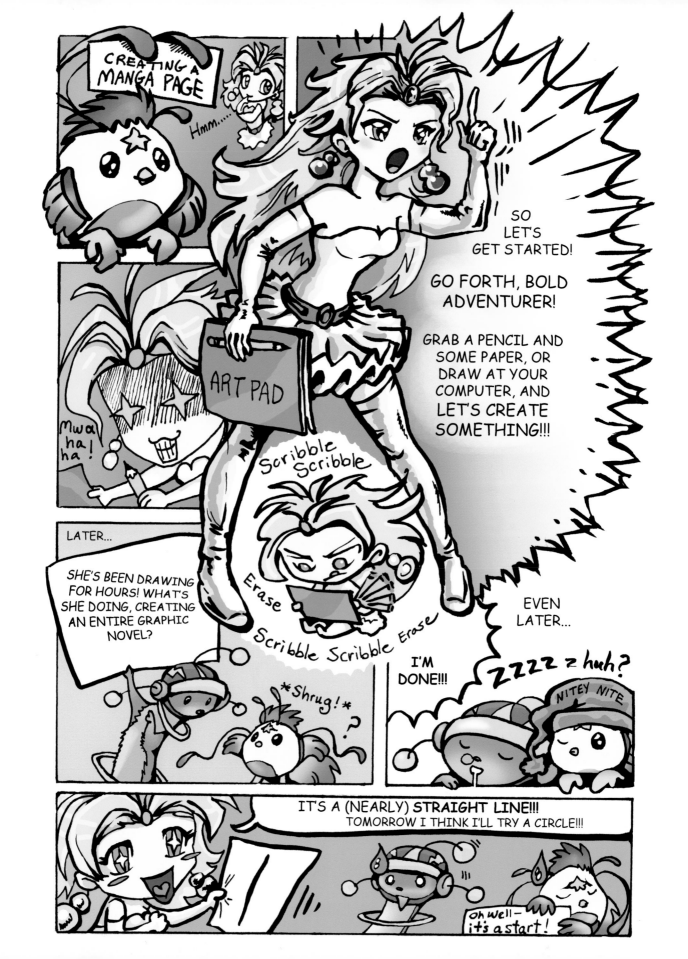

USING THE COMPUTER TO CREATE MANGA ART

COMPUTER TECHNIQUES

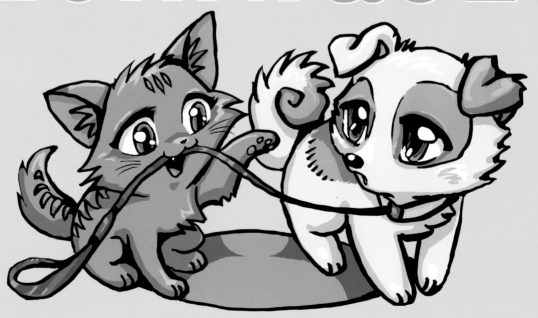

Today, computers are an important part of creating and publishing comics, and manga is no exception. Computers have made it easier to combine clean and crisp art and text on a page and to print out a professional-looking final result. Some artists use the computer exclusively, while others use a combination of hand-drawn and computer-generated images and text.

In this chapter, I've included several full-color, step-by-step art demonstrations, ranging from simple drawings to putting together a comic page. I've included keyboard commands for both PC and Mac users. Detailed instructions explain how the artwork was created in either Adobe Photoshop CS3or Corel Painter X, two popular image-manipulation programs in widespread use. You may use different versions of these programs or even a different art creation program, but the basic steps steps required to create a similar image on the computer are generally the same. You may want to try your hand at copying one of these projects, or you may prefer to study the techniques I used and then incorporate them into the creation of your own artwork. I encourage you to use my projects as a jumping-off point, and then continue to learn more about the computer program or art medium you will be using.

You can use a computer mouse to create art, but may find it somewhat awkward. So I recommend getting a graphic tablet (such as a Wacom tablet). Graphic tablets allow you to draw and color in the computer with the same ease as if you were using a pencil and paper. I used a Wacom tablet extensively to create the illustrations throughout this book. In addition, a good scanner is a valuable tool for creating manga art, especially if you like to draw by hand on paper and then scan your art into the computer to add your finishing touches.

PUPPY AND KITTEN: DRAW, THEN COLOR IN PHOTOSHOP

FOR THIS PROJECT, I wanted to use two common animals found in manga: the dog and the cat. I also wanted the drawing to be very cute, crisp, and clean looking. Photoshop is great for clean lines and blocks of color. In addition, I wanted to mimic the look of an anime *cel*. Animators used to draw and paint on transparent sheets (cels) to create a series of drawings for animation; now it is usually done almost entirely on the computer. Japanese anime cels often featured layers of complex shadows and highlights with hard edges to them. Manga art relating to those anime series often echo that look.

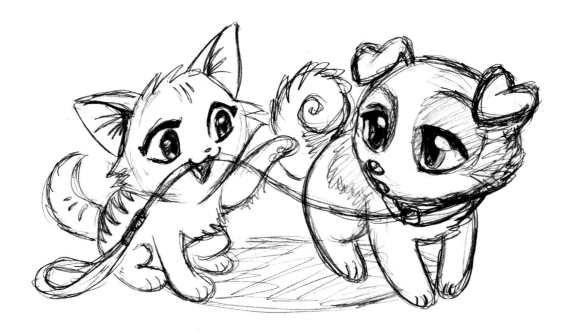

DRAW

This is a drawing of a cute, fairly simple puppy and kitten that will be colored in Photoshop. First, I sketched the two animals interacting with each other, using a mechanical pencil.

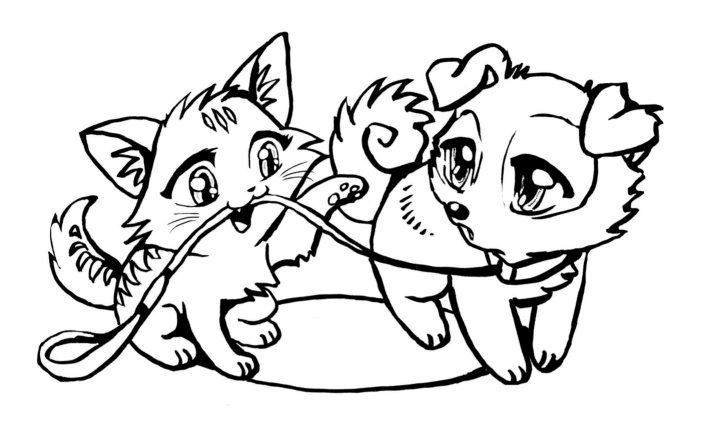

INK YOUR DRAWING

Next, I used a Copic Sketch Marker (100 Black) to ink in the drawing. Once it was dry, I erased the pencil lines underneath and scanned it in Photoshop at 600 dpi. (For most applications, including printing from the computer at home, 300 dpi is sufficient for good-image quality while keeping one's file sizes to a minimum.) Once scanned, I used Images: Adjustments: Curves and Images: Adjustments: Brightness Contrast to brighten and increase contrast in the image. Finally, a Hard Round Brush tool came in handy to clean up the drawing and prepare it for coloring. Convert the drawing to RGB color mode if you have not done so yet.

PREPARE YOUR IMAGE FOR COLORING

There are many ways to prepare the image for coloring, and here is one:
Duplicate the layer in Photoshop [**PC Shortcut: right-click, Duplicate Layer; No Mac Shortcut**]. Then delete the background layer, which is locked, and duplicate the existing layer again. You should have two identical (unlocked) layers: Background Copy and Layer 1, which will be on top. Select Layer 1 and go to the Channels menu, which is near the Layers menu. Click on Load Channel as Selection, which is an icon that looks like a dotted circle on the bottom left of the menu. This selects all the white in your image. Hit "Delete" and all the white goes away, leaving only the black outline on your top layer. Now you can go to Background Layer and color it in without messing up the outline. Deselect the selection (Select: Deselect).

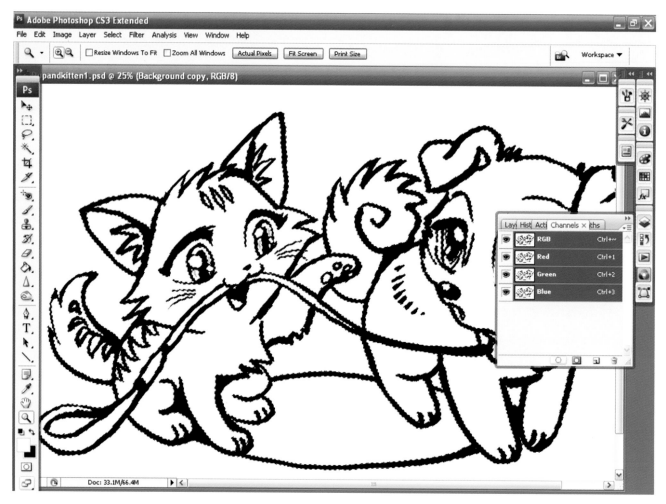

COLOR YOUR IMAGE

I chose the kitten, using the Paintbucket tool [**PC & Mac Shortcut: G**] to quickly fill in a blue-gray color. This is a rough stage, so it's OK that the eyes and other areas are not perfect. At this stage, I continue to fill in broad areas of color to get an idea of how they are working together in the image as a whole. Next, the puppy was colored in using a Hard Round Brush tool to block in colors as needed. I wanted to keep a sense of harmonious color between the two animals, so I used some of the blue of the kitten for the puppy's eyes, some orange from the puppy on the kitten's stripes, etc. Use the Eyedropper tool [**PC & Mac Shortcut: I**] to select the color you want. The image also uses complementary colors to make the colors "pop." Blue and yellow are complementary colors, so the blue and yellow-orange in this image have some of that "pop factor." Finally, I selected the beige from the dog and used a paintbrush tool to color in the kitten's eye whites; then I used purple for the "shadow" rug at the animals' feet.

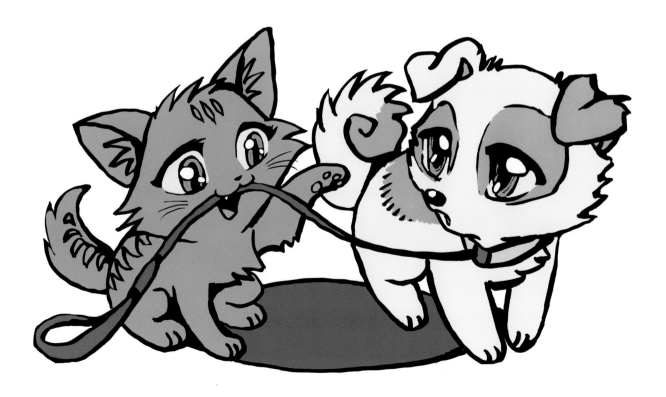

ADD SHADOWS

Now satisfied with how the colors were working together, I was ready to put in shadows. Manga and anime can have either hard-edged or soft-edged, subtle shadows, but the hard-edged version is perhaps the most well known for the art form, so that's what I decided to do here. (Pick an airbrush instead of a hard brush in the Brushes menu box to achieve a softer effect.)

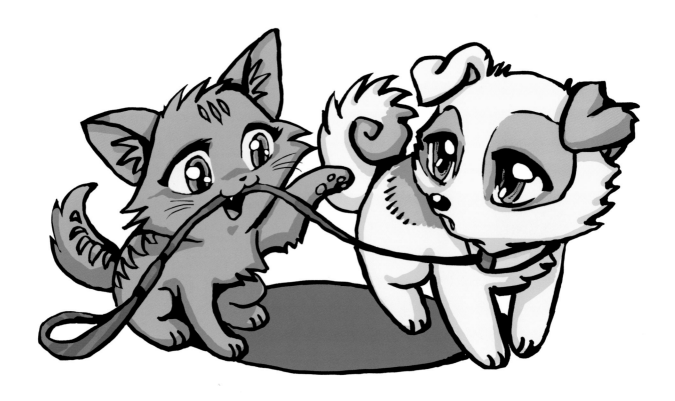

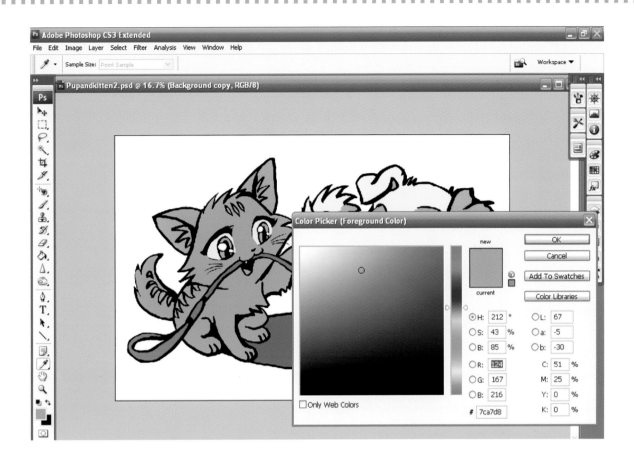

SELECT COLOR

First select the blue of the kitten's coat using Set Foreground Color menu box on the bottom of the toolbar (at the forefront of two color boxes). On the Color Picker menu box, use the mouse arrow (now shaped as the Eyedropper tool) to select the blue of the kitten. Choose a slightly darker blue inside the window for the shadow color. Click "OK."

Before you start to color, select the blue in the image [**PC & Mac Select: Color Range**] and make sure the Fuzziness slider selects just the color you want. With only the light blue selected, you can now paint the darker blue over it without affecting any other color. Use the Brush tool [**PC & Mac Shortcut: B**], and select the hard brush from the top menu "Brush preset picker." I set the brush at 70 pixels diameter for a 600 dpi image. Add a darker blue, hard shadow on the kitten's body. Note that the puppy's blue eyes are also selected—you can shade them in, too. If you feel at any time you've darkened too much, select the lighter color again [**PC & Mac Shortcut:** I to use the Eyedropper tool for color selection] and paint some of it back in. Now do the rest of the image this way, selecting an area to work on and adding shadows. The light source (in this case, coming from above) should remain the same or the two figures will look like they don't belong together. For the kitten's green eyes, I used the Wand tool to select the color and darkened the center of the iris. I also decided to change the color of the hair in the kitten's ears to the blue of its body fur.

ADD HIGHLIGHTS

Highlights should be used sparingly, unless you're going for an extra sparkly image. For this picture, I added carefully chosen highlights in a few areas that I thought the light might hit extra brightly or to places I wanted the viewer to focus on. Highlights were added to the top of the heads, ears, tails, noses, cheeks and a few on the paws, eyelids and also on the chest of the kitten. Here, too, I used Select: Color Range if I was concerned about overlapping onto another color, and the Eyedropper tool and the Set Foreground Color menu box to select a slightly lighter hue from the base color I was working with. Lastly, I added some variation to the rug below them because it was composed too much of one solid color.

FINAL TOUCHES

Finishing up the picture, I went back to fine-tune any last details, adjusting shadows and highlights, including the eyes. I used the Wand tool [**PC & Mac Shortcut: W**] and made sure the Tolerance was set high enough to select everything I wanted but without selecting extras I didn't need. Selecting the beige of the eyes of both the kitten and puppy, I used a Hard brush to fill in most of the eye whites with white. I left only a small layer of beige under the eyelids for shadow (to suggest that they overlap the eyeballs). Deciding I wanted a new color, I again used the Wand tool to select those shadowed beige areas and colored them light blue instead. Lastly, I added some darker blue to the puppy's eyes.

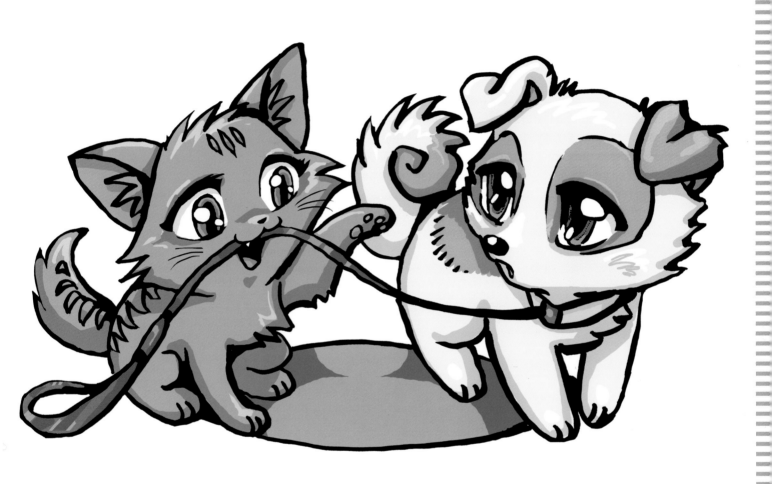

The final image with color, shadows,
and highlights added in photoshop

FOX: SKETCH BY HAND, THEN FINISH AND CREATE IN COREL PAINTER

FOR THIS COREL PAINTER DRAWING, I wanted to create something soft, decorative, and rich in color and texture. Corel Painter is ideal for creating a painterly, rich, and textured piece of artwork. Manga and anime art is well known for featuring solid blocks of color, hard lines, and crisp shadows (see the Puppy and Kitten Project on pages 104–111). However, sometimes manga artists choose much softer shadows and highlights, adding texture and subtlety to their art. Some popular Japanese video-game characters are depicted in this more painterly way. A fluffy fox sitting beside pink cherry blossoms fits this project well. In Japan, many people enjoy picnicking under flowering trees during springtime cherry blossom festivals. As a result, cherry blossoms and trees are a popular motif in many anime and manga drawings. The fox is also holding chopsticks and a bowl of kitsune udon (see pages 86–87), a Japanese dish said to be a favorite of this species.

DRAW

I sketched this fox with pencil on paper to make sure I had the basic look I wanted. Her appearance is based on various manga and anime foxes I've seen. Once scanned into Corel Painter, this drawing will serve as the basic guideline for my work.

FOX ANATOMY

Here I've used a red line to indicate the underlying anatomy of this somewhat anthropomorphic fox, using circles and a very simple skeleton. (This red line was created using a small brush in Photoshop.) I also indicated some of the areas where lines flow together in her face and create a harmonious rhythm.

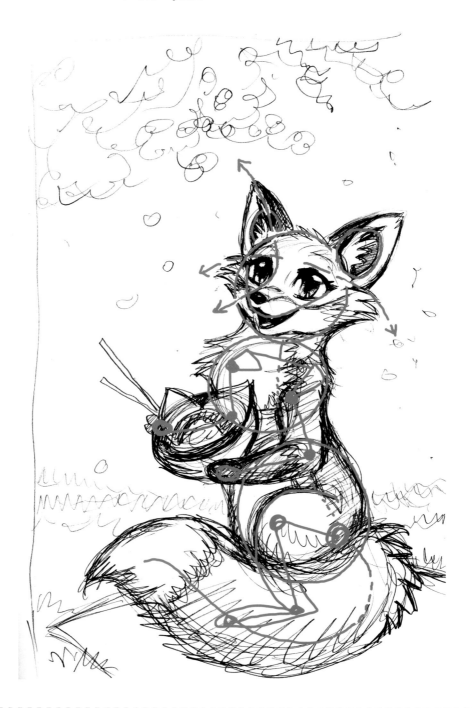

COREL PAINTER

I opened Corel Painter and created a new image (8 inches wide, 10 inches tall, and 600 dpi). Opening my scanned image (which I named "Foxsketch" in Painter), I copied and pasted it onto my new canvas. The resulting image was too large, so I used Effects: Orientation: Free Transform to scale down the sketch to the same size as the canvas. Make sure you have set Brush Tracking in Painter [Edit: Preferences: Brush Tracking]. This helps customize Corel Painter's sensitivity to your individual brushstroke pattern while using the stylus or mouse. To begin, I created a new layer on top of the sketch layer to draw in my final "inked" lines. You can use a variety of brushes for this task; I chose the Pen: Croquil Pen 3 set at Size 11. (As with Photoshop, use the curly bracket keys { } to make the brush size smaller or larger. Also, use the Magnify tool [**PC & Mac Shortcut: M**] to zoom in and out, and use the Grabber tool [**PC & Mac Shortcut: G**] to move the image around.) Draw a finished line version over the rough sketch. I used dark brown for much of the outline but black in areas like the eyes and mouth. You can set the opacity of the scanned image ("Foxsketch") layer to about 50% in order to better see what you're doing.

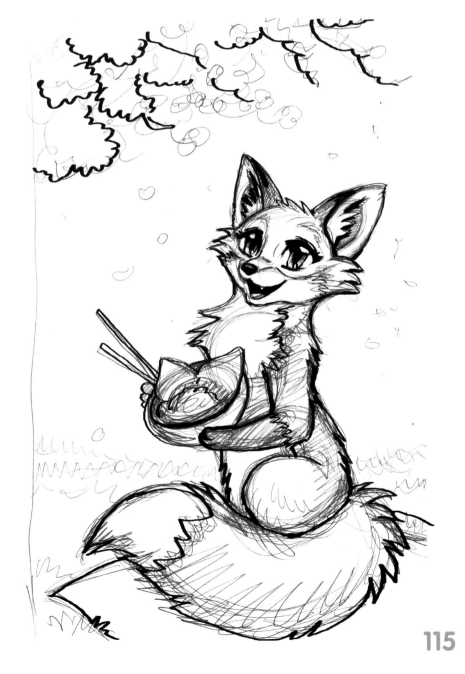

COLOR IN IMAGE

Once you're done drawing the line art, go to the layer with the original "Foxsketch" on it, and begin coloring in the image. (The line layer above will not be affected.) I went to Real Bristle Brushes and selected the brush Real Tapered Flat and colored in a base orange. If you're working on an earlier version of Corel Painter and don't have that brush, I find that Artists Oils: Bristle Oils 20 works well, too. You can also use the Paint Bucket tool to fill in large areas with color, but be aware that it may leave grainy white spots that need to be painted in with a brush. Some artists choose to create two layers, working on the subject on one layer and the background on another. I wanted a painterly give-and-take between subject and background for this piece, so I kept to one color layer. Using the same brush, I colored the rest of the image with flat, basic colors.

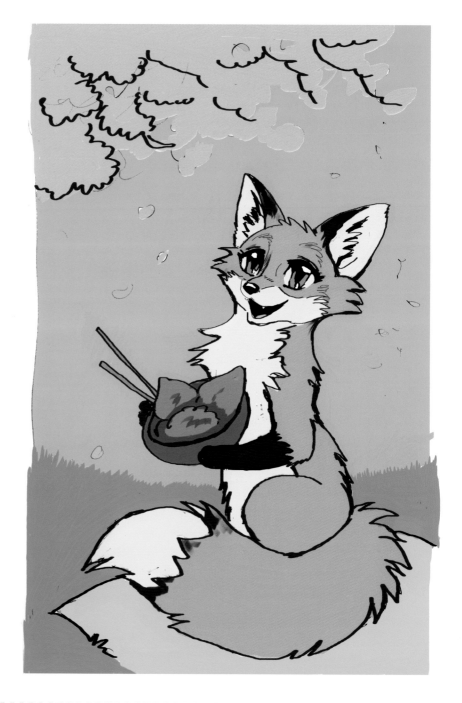

ADD SHADOWS

Using an Artists Oils: Mixer Thin Flat brush at about Size 29, I filled in shadow areas with blue-purple. The Mixer Thin Flat brush starts with the blue I selected, but rapidly blends it with the base color on which it is painted (orange) to create a nice blend of blue shadow and orange-brown base tone. When I got to the eyes and facial areas, I reduced the transparency of the brush to 35% to create more subtle effects. I used the same brush (at 100% transparency) for the background as well.

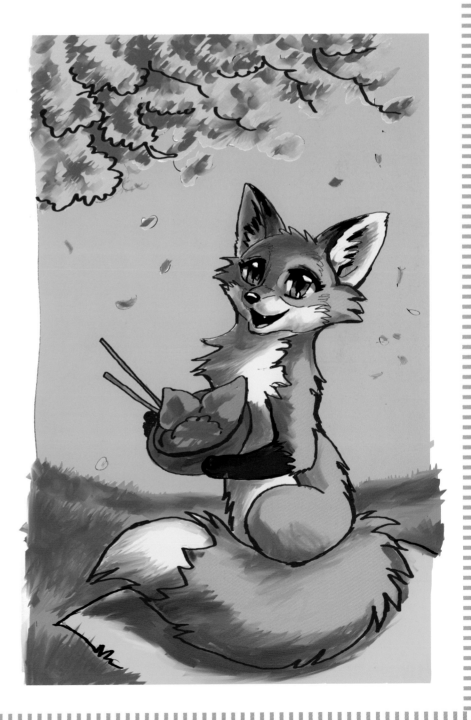

ADD HIGHLIGHTS

After working on shadows, it was time to add highlights. Using the same brush, I selected pure white and added highlights to brighten areas on the fox's face, belly, and tail. Then I selected a bright yellow-orange and blended it into the body.

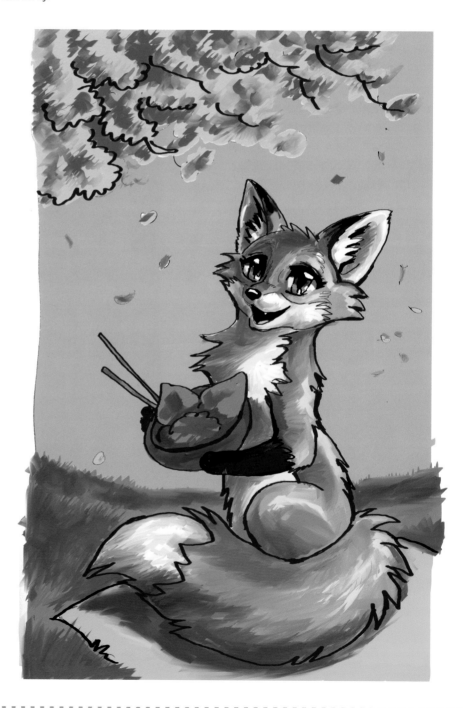

PAINTERLY EFFECT

I was going for the painterly effect seen in a lot of Capcom game art and illustrations from *Dragon* and other Japanese manga magazines. It is a painterly look, but still contains solid areas of color and distinct shadow planes on the figure. I noticed that the fox was becoming too blended, so I went back with a nonblending brush and filled in some flat areas of orange again. (I used the Smeary Impasto from Artists Oils to do this.)

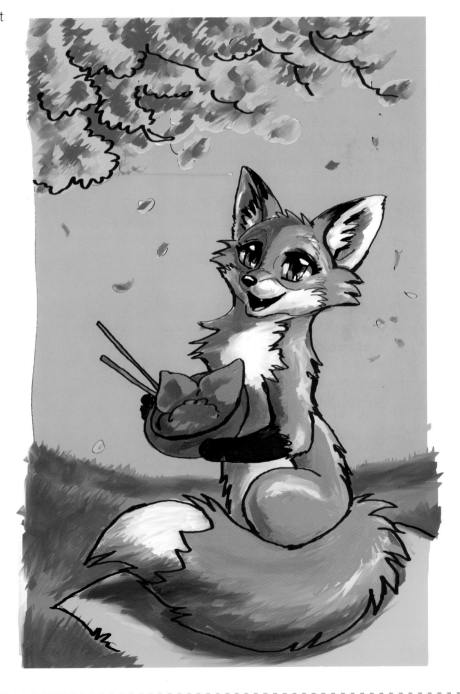

ADD MORE SHADOWS AND HIGHLIGHTS

At this point, I began to work on finalizing various elements in the painting. I added shadows and highlights and a tan color to the kitsune udon and the bowl, as well as working on the picnic blanket and grass. The green of the grass was darkened and shadows were made more pronounced. I worked on the shadows and coloring of the fox's body. Most of the time, I used brushes at 100% transparency, though sometimes a subtle touch required me to set the brush at about 30%. If I seemed to be losing some of the distinct planes of the body shape, I used an Artists Oils: Clumpy brush to again paint in more solid blocks of color. Going back and forth between shadow and light, I worked on maintaining blocks of color that blended into each other. The fox's tail still seemed too light compared with other shadowed parts of her body, so I darkened the shadow there a bit.

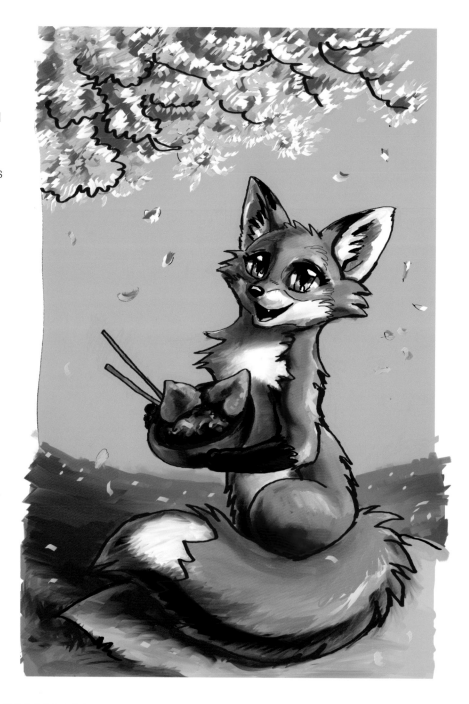

Using the Artist Oils: Mixer Thin Flat brush, I added slashes and strokes of white and then pink in the branches and below, to indicate petals falling to the ground. A darker blue-purple was added to give some shadow and depth, and then I switched to the Artists Oils: Oil Palette Knife to smear and soften the strokes. At this point I began to feel that the painting was coming together. It can be hard to know when to stop, but I felt that the painting looked fairly good (as opposed to "horrible," which is when you keep working on it!). For me, "fairly good" is a sign that I need to slow down and consider that I might be nearly done. Some of the line art on the layer above the color layer was beginning to irk me, so I went to that top layer and used the Eraser tool to take out many lines in the tree branches. When I was finished, I used the Pen: Croquil Pen 3 (Size 17) to draw in a few lines to indicate tree branches where I thought appropriate.

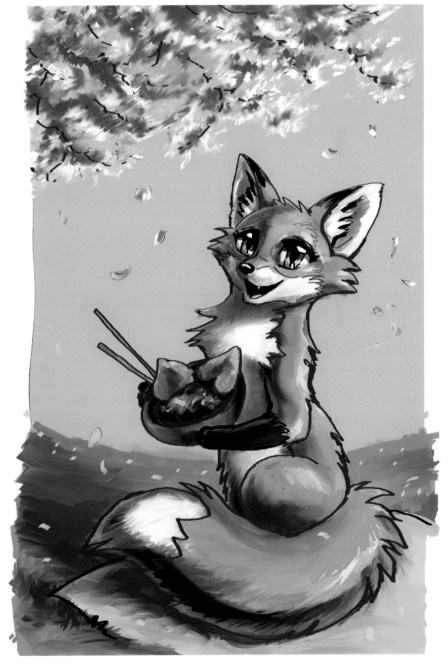

FINAL TOUCHES

I refined a few details, still aiming for a sense of flat blocks of color that are somewhat blended together. I worked with the line art layer and erased or redrew it as I saw fit.

1. In the Layers menu, I selected the bottom-most layer, Canvas, then chose Layers: Drop All in the menu bar. Doing so will flatten the layers.

2. Now it became possible to work on fine-tuning the eyes, mouth, and other areas that were not open to blending before (e.g., defining details like the highlights and irises of the eyes). With the Croquil Pen 3, I went back to the cherry flowers and added dabbles of pink and then white to paint in individual blossoms. I also added a little sky color to make the tree seem less dense and added in details and lighter color to the branches. Lastly, I used the Croquil Pen 3 to draw a pink and then blue border on either side, reworking or erasing as needed, and adding white to the border again.

3. Using the Magic Wand tool, I selected the bands of pink and then chose a slightly lighter shade of pink. Using the lighter pink to brush over the selected area, I let the old color show through occasionally for a dappled effect. I also used the pen (white) to create a scribbly effect that mimicked the shape of the flower petals.

4. The sky background seemed too "solid" compared with the somewhat mottled, dappled effect I was getting everywhere else, so I used the Artists Oils: Mixer Thin Flat (white) to lightly brush in some clouds. It was then that the kitsune udon—eating fox was finally done!

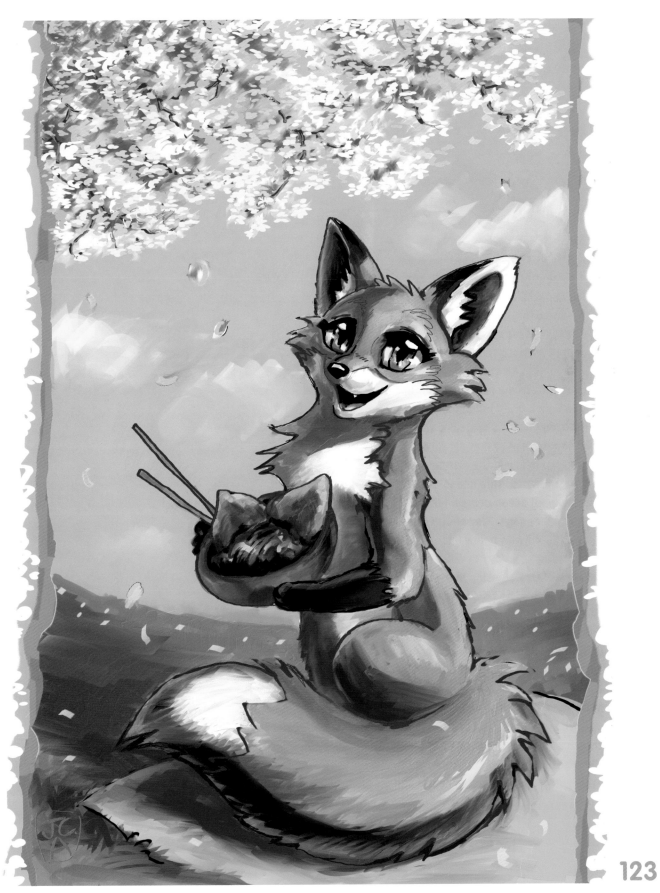

DRAGON: DRAW BY HAND, THEN COLOR IN PHOTOSHOP

THIS JAPANESE DRAGON is a more sophisticated manga drawing reminiscent of Japanese scroll art, which is partly responsible for manga as we know it today. Specifically, this drawing is inspired by *ukiyo-e,* or Japanese wood-block prints and paintings popular from about the seventeenth to the twentieth century. Manga was heavily influenced by ukiyo-e, so I wanted to depict some common themes of that art form here—especially in the rolling of the ocean waves. This image evokes the powerful ocean dragon king in a moonlight scene. His sea turtle messengers swim below him in the waves. I found it easy to visualize the essence of this drawing in my head right away, and so I didn't have to sketch it out for too long before I came up with the underlying pencil drawing shown here. This is a pleasant surprise when it happens. However, sometimes a drawing requires you to make many sketches before you come up with something that pleases you. This drawing has a strong figure eight composition, guiding the viewer's eye in an eight-shaped pattern round and round the image.

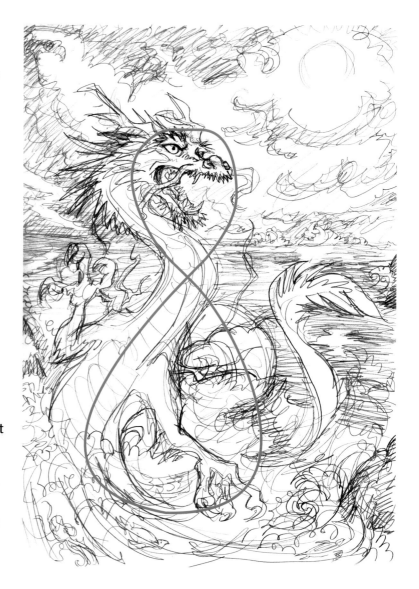

I colored this piece entirely in Photoshop.

1. After inking the drawing, it was scanned into Photoshop as grayscale at 600 dpi.

2. I used Image: Adjustments: Curves [**PC shortcut: Control + M; Mac Shorcut: Command + M**] and Image: Adjustments: Brightness/Contrast to strengthen the contrast of the drawing and to get the solid black lines I wanted in order to begin coloring.

3. It was then converted to RGB color mode.

PREPARING TO COLOR

1. First, I went into the Layers window. There was already one default layer called "Background." I chose Layer: Duplicate Layer [**PC Shortcut: right-click on Background Layer and choose Duplicate Layer; Mac Shortcut: Command + J**].

2. Instead of naming it the default "Background Copy," I renamed it "Color." The "Color" layer is where I would begin coloring the image. But first, I wanted a layer for black line art only above the "Color" layer that would not be affected by my painting.

3. With the "Color" layer active, I chose Select: Color Range, a Fuzziness of 175, then chose "Selection" and Selection Preview: None. Selecting the black lines, I hit "OK," which selected the black line art.

4. In this step, copy and paste the line art. [**PC Shortcut: Control + C (Copy) and then Control + V (Paste). Mac Shortcut: Command + C (Copy) and Command + V (Paste)**] This creates a new layer consisting of just the black line drawing above the background and color layers. To rename it, double-click the layer. I named it "Line Art." To see what just that layer contains, click on the "eyes" to the left of each layer below it. Click the empty squares to bring the "eyes" and the layers back to begin working on the piece.

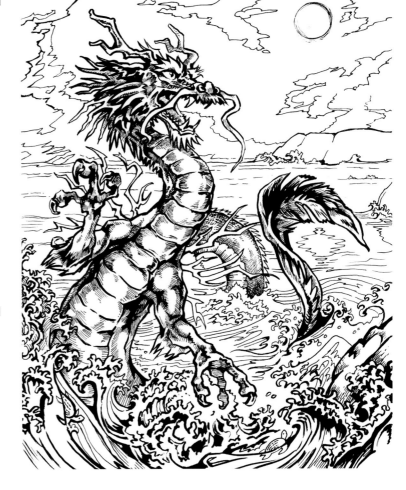

Important: At this point, be sure to remember to select the "Color" layer so that the line-art layer above it is left untouched as you work.

COLOR WITH THE BRUSH TOOL

This dragon drawing is complicated, so I used mostly the brush tool [**PC & Mac Shortcut: B**] to hand-color in blocks of basic colors. In this drawing, I selected a hard round brush.

1. Use the curly bracket { } keys to make the brush smaller and larger as you paint with color throughout the image.

2. Use the Paint Bucket Tool [**PC & Mac Shortcut: G**] when possible to fill in larger blocks of color. At this point, getting the exact colors right isn't

necessary because one can always go in and change them later. (To do that, chose Select: Color Range, use the Eyedropper slider to select the color you want, use the Fuzziness slider to select just that color and none other, and hit "OK." Then color with the Brush or Paint Bucket tool, and it will only fill in that part of the image.)

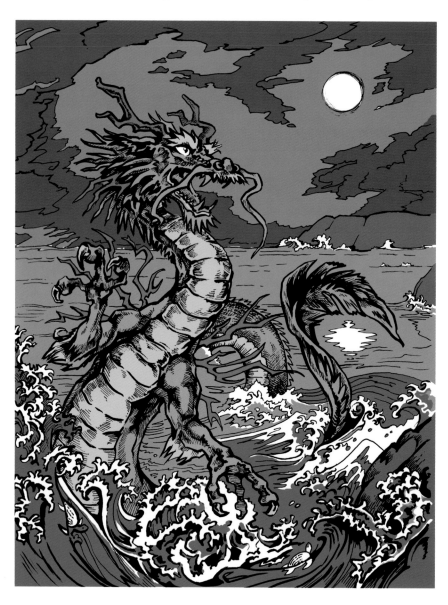

ADD DETAILS

Now that the time-consuming part of filling in the basic color is completed, it is time to begin fine-tuning the piece. I decided to start with the ocean, using a darker blue in the foreground waves and a lighter blue for water in the distance. The Hard Round Brush tool was used to block in and mix these colors where they meet in the middle and foreground. I added white where needed.

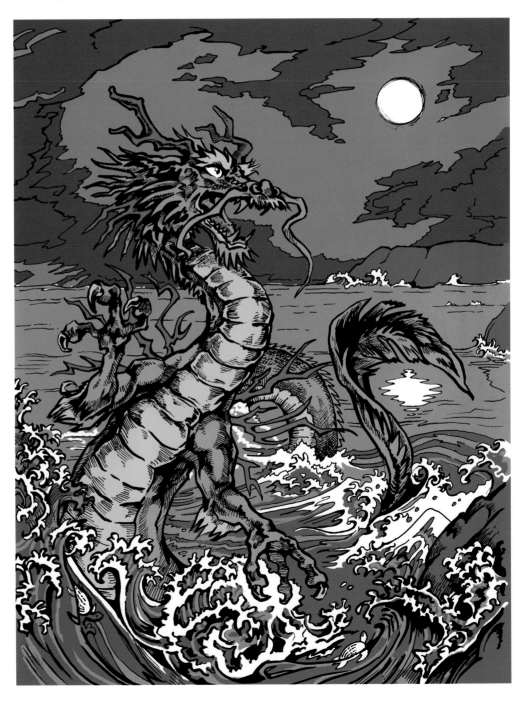

Screen Shot: Selecting a brush.

ADD SHADING AND DEPTH

Next I wanted to work with more subtle shading and add some depth to the ocean.

1. Using an airbrush soft round at about 50% opacity, I added some light details on the horizon. I selected the blues of the ocean (using Select Color Range) so that nothing else (e.g., the dragon) would be affected by my coloring.

2. Then, after enlarging the brush, I used a very faint opacity (13%) to sweep quickly across the horizon, making it lighter so that it appeared to recede in the distance more. I swept the brush a few more times across the most distant part, lightening it even further.

Screen Shot: Using Color Range to select the ocean.

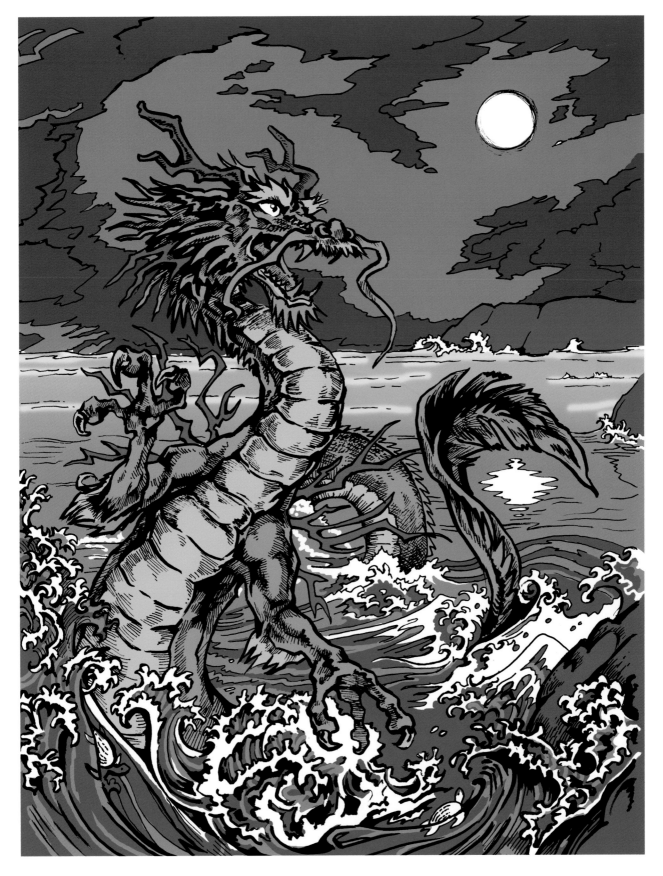

Result.

Screen Shot: Using the Gradient tool.

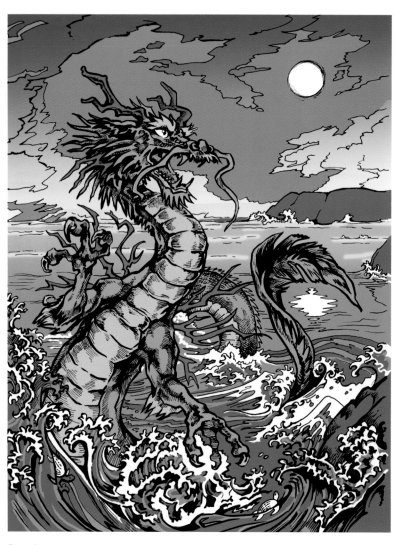

Result.

GRADIENT TOOL

The clouds needed some work, so I used Select: Color Range to choose the clouds overhead. Choosing the Gradient tool [**PC & Mac Shortcut: G**], I selected a gradient of darker gray to lighter gray. The Gradient Tool was set at Normal and 100% opacity. I filled in the clouds to achieve an even transition of dark to light.

MAKING A CUSTOM GRADIENT

1. I used Select: Color Range to select the rest of the sky. To make a custom gradient, go into the Gradient Tool editing box by clicking the Gradient color bar on the left top of the screen.

2. Clicking on the tabs above and below the color bar, I selected 100% opacity and a range of light green-gray to slightly darker green-gray than was there originally. I clicked "OK," then made a selection from the bottom to the top of the clouds.

3. The color was then filled in so that the dark areas would be lower on the horizon. I liked the result, but wanted to darken or lighten a few areas, which I then did (while the sky was still selected) with an airbrush tool set at a low opacity (11%). I also selected a light blue color from the ocean (using the Eyedropper tool [**PC & Mac Shortcut: I**]) and painted just a hint of that in the sky using the low-opacity airbrush.

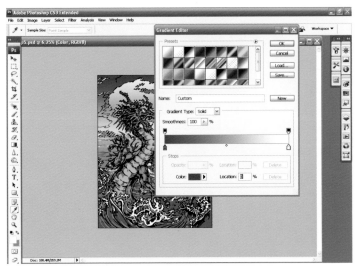

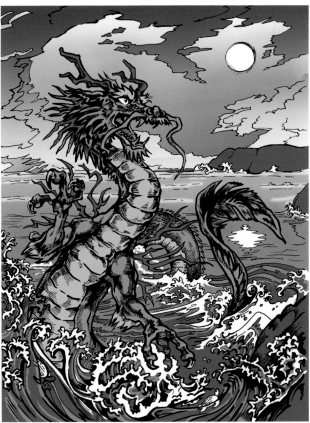

TOP LEFT: Screen Shot: Selecting the sky.

BOTTOM LEFT: Screen Shot: Using the Color Gradient tool. You can see the various shades of gray-green used in the sky.

RIGHT: Result.

131

Onto the rocks! I used Select: Color Range to select the brown rocks lining the shore.

1. The Spatter brush was set at 50% opacity, and I selected a color slightly lighter than the rocks' base hue. I painted the highlights into the rocks, trying to keep their textured look, then chose a darker color for the shadows.

2. After adding those shadows, I chose an Airbrush tool and selected a dark blue color from the ocean. Using it at low opacity, I swept the brush over the distant rocks, using the dark blue to make the rocks recede in the distance.

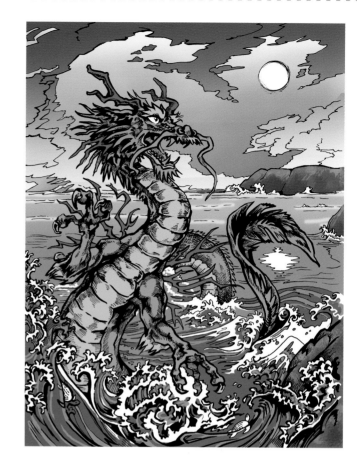

Finally, the dragon itself! I selected the green part of the dragon using Select: Color Range.

1. Then I used the Wand tool [**PC & Mac Shortcut: Shift** (to add to your existing selection) + **W** for Wand] to select the red spikes on his head and his yellow belly and hair. I left out his eyebrows and the spikes emanating from his back. First, I painted over (at 50% or so opacity) some of the bright red areas to tone them down.

2. Then I used the Eyedropper tool to select a dark blue slightly deeper than the ocean color. I used the same low-opacity airbrush to reflect the blue color of the ocean onto the dragon's green body. This reflective color makes the dragon blend in slightly with his environment and not look like a cardboard cut-out.

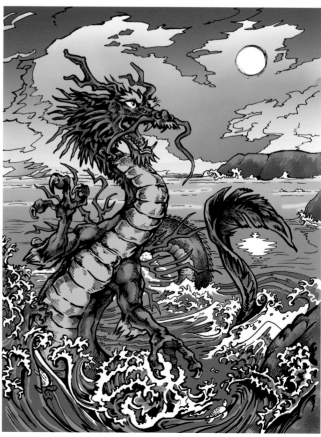

USING BRUSH, DODGE, AND BURN TOOLS

Next, I selected the Dodge/Burn tool [**PC & Mac Shortcut: O**] and proceeded to lighten and darken areas that needed more three-dimensionality. (The Dodge tool was set on Highlights, with Exposure: 30%. The Burn tool was set on midtones, with Exposure: 50%)

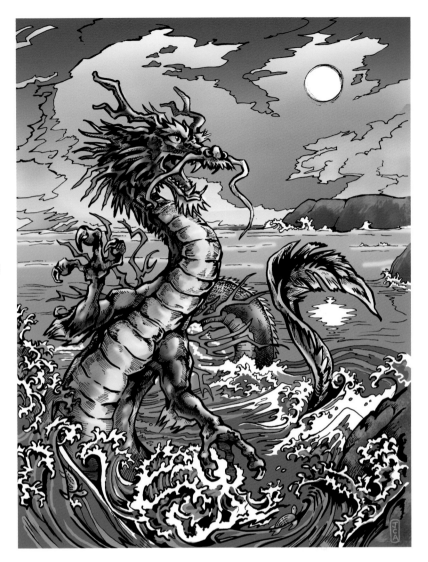

1. After deselecting the dragon's body, I selected the red back spikes and eyebrows with the Wand tool [**Hit "Shift" + "W"** to select multiple areas at a time]. I used Dodge/Burn and Airbrush to adjust colors and add depth.

2. At first, I added blue to the dragon's eyes, but somehow that didn't work—I think the blue was too close in tone to the sky background, so it didn't "pop out" enough. Then I tried red-yellow eyes, and those popped better, but something was still missing. Then I tried adding a faint dragon green to the red-rimmed eyes—and that worked best. (The green reflects his body color and is effective as a complementary color to the red.)

3. I used Brush and Dodge tools to add shadow, light, and depth to the eyeball. A reduced-opacity white was chosen to add a rim of moonlight hitting the far side of the dragon's face. Brush, Dodge, and Burn tools were used to emphasize light and shadow on the face and figure of the Sea King. I added a hint of red to his tail to let that color flow through the picture. The green sea turtles swimming below the dragon were colored in, and the Dodge tool was used to lighten their shells. The sky and clouds still looked a little flat, so I used a low-opacity airbrush to add hints of ocean blue to the clouds near the horizon. The reflected color unifies the upper and lower background of the piece.

4. Finally, I signed my initials on the right bottom corner, using a vertical box reminiscent of Japanese scroll art text. Deciding that the signature was too dark, I used the Wand tool to select all of it and used the Dodge tool to lighten it up in places.

FINAL TOUCHES

After taking some time away from my illustration, I returned to look at it and perceived that the background dominated the picture a bit more than it should.

1. I lightened the background, especially in the cloud areas, to reduce overall contrast. This helped make the dragon's head (which had heavy contrast) "pop" out more. Paying attention to little details like this can really help make an image look its best. Next, I went to Layer: Flatten Layer to ready the image for use as a TIFF or JPEG format. If the image is for print only, it can be printed out in Photoshop without flattening layers.

2. The image flattened and looked a bit darker than I wanted, so I went into Image: Adjustments: Curves [**PC Shortcut: Control + M; Mac Shortcut: Command + M**] and tweaked it a bit to lighten it up without losing quality. (Image: Adjustments: Levels is perhaps a bit faster and easier to use, but it reduces image quality, so I try to avoid it.) I also used Image: Adjustments: Hue/Saturation [**PC Shortcut: Control + U; Mac Shortcut: Command + U**] to heighten the color, which had become a little bit dull.

Selecting Image: Adjustments: Curves from the menu.

Screen Shot: Adjusting curves
NEXT PAGE: Voilà! A Japanese Sea Dragon King ready for his debut.

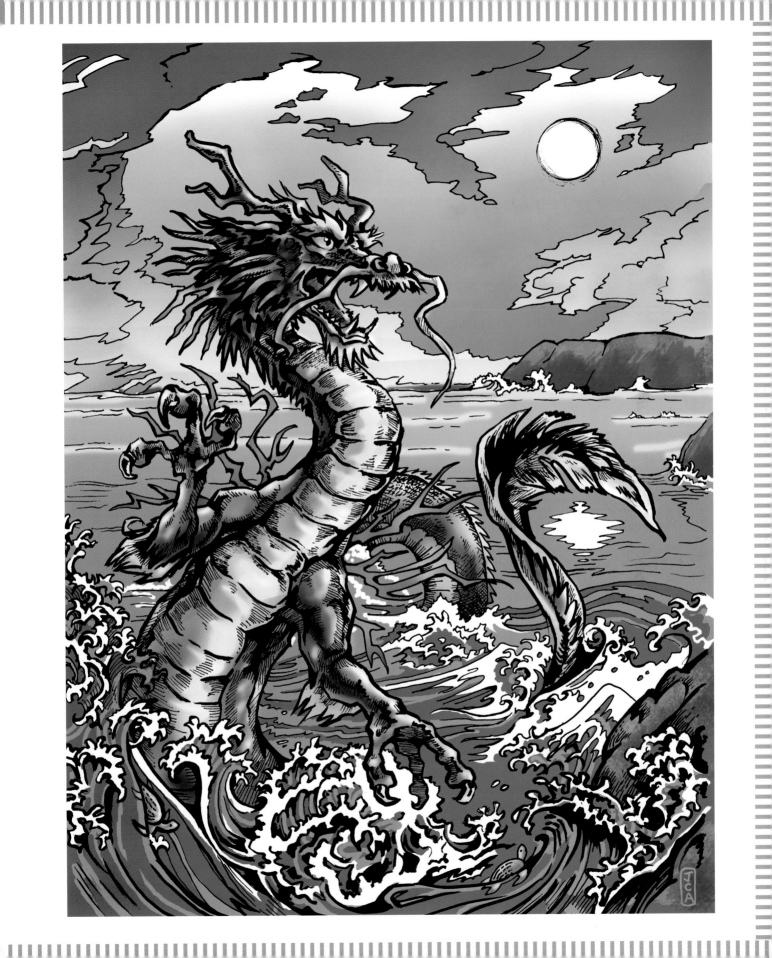

MAKE A MANGA PAGE: DRAW BY HAND, THEN COLOR IN PHOTOSHOP

THIS SECTION FOCUSES ON BRINGING A MANGA STORY TO LIFE, from the first kernel of an idea through to a finished page. Some Photoshop tools are mentioned here but are not covered in depth. For a more detailed explanation of how to use these tools in Photoshop, please see the Puppy/Kitten project on (pages 104–11) and the Dragon project on (pages 124–135).

When I'm ready to draw a finished manga page, I like to use good-quality paper that will allow me to sketch, erase, and ink without scratching or having the ink bleed on the paper. There are several good drawing pads and papers available on the market, including Bristol board drawing pads or even specialty drawing pads made with manga artists in mind. Look for acid-free paper that is thick enough to withstand erasing and inkwork.

The dimensions of a professional manga art page vary slightly depending on the publisher, but 10 by 14 $\frac{1}{4}$ inches (or up to 14 $\frac{7}{8}$ inches) seems to be fairly standard for Original English Language (OEL) manga. (OEL is manga produced by a western artist using the Japanese style.) The "safe zone," or live area, for artwork on this page is about 9 by 13 $\frac{3}{8}$ inches. Anything outside the safe zone may get cut off during printing, so make sure no text or important artwork lies outside that zone. I produced the comics for this book on a Canson Fanboy Manga Art Board sketch pad specifically made for the task and sized at 10 by 14 $\frac{1}{4}$ inches.

Even if you don't have access to these kinds of items but are planning to scan your work into a computer, you can draw on whatever paper you have. The key thing is to start drawing! Of course, if you're drawing directly on the computer using a mouse or artist's tablet, you don't need to worry about paper. But keep in mind the size I mentioned—it's a good, standard size for creating a manga comic book either on paper or on a computer. And it can be reduced later with no loss of quality. However, a small drawing or page of drawings cannot be resized as a larger page—the image quality will be too poor to be usable.

Leyra - So now to start a project!

- GO FORTH BOLD, ADVENTURER!

- works several panels over art project, var. express.

- TA DA! It's finally finished! It's a straight line! ...tomorrow I'll try a CIRCLE! woohoo! SC/SW: oh, well, it's a start!

BRAINSTORM

To begin creating a manga comic book page, you must first come up with an idea. Think of the characters you want to use in your comic story, and think of a funny, dramatic, or otherwise interesting scenario in which to place them.

Sometimes an idea will come to me before I can take the time to sit down and draw. If so, I jot down a note (like this one for my third comic) to get the gist of the idea on paper.

DRAW

When I have the time to draw, I sit down with a pad and begin making a rough sketch to lay out my idea visually. Remember that manga has a cinematic "flow" to it, so don't be afraid to overlap images. Just be sure the comic is readable, that is, it gives the eye an easy path to follow down the page, or it will be too confusing.

RIGHT: Here is a very rough version of the second comic. I worked out the placement of some basic shapes (panels and characters' heads) on the manga art paper I was using. I wanted to make sure the layout looked appealing and readable, and that the proportions were correct.

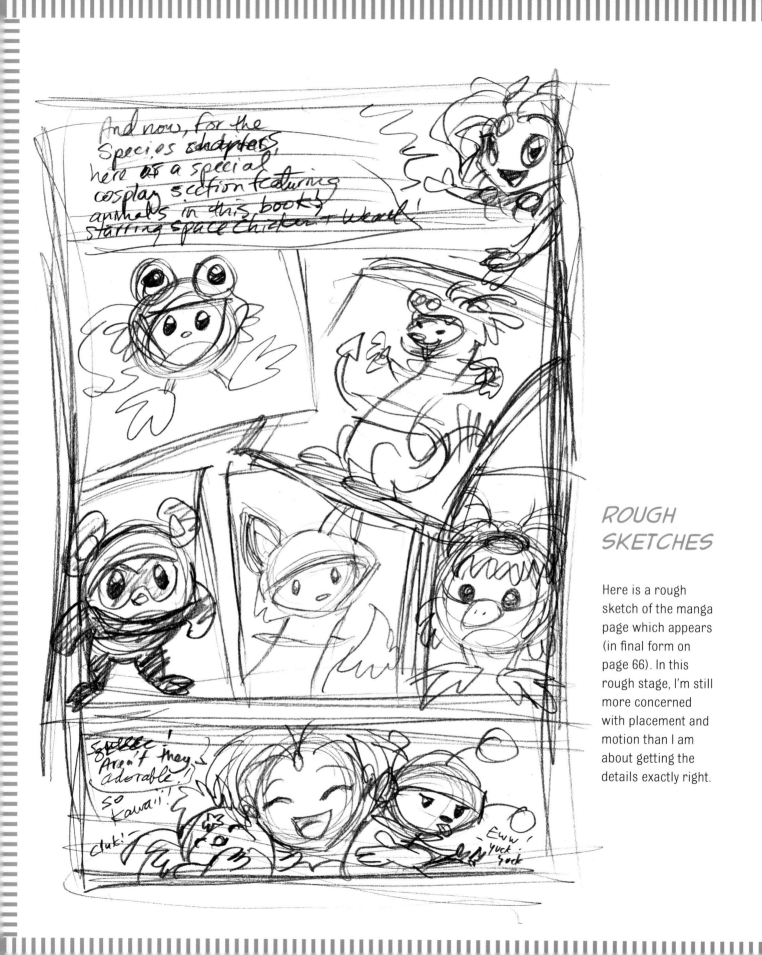

ROUGH SKETCHES

Here is a rough sketch of the manga page which appears (in final form on page 66). In this rough stage, I'm still more concerned with placement and motion than I am about getting the details exactly right.

Above is a rough sketch of the manga page which appears (in final form on page 100).

I write in the text here to get an idea of whether the words will fit on the page. Later, when I'm working on the final version, I usually type in the text using the computer.

Sometimes, the way I first roughed out a page turns out to be the best version. Other times, it can take several attempts to get the right layout. Here is one layout I didn't use for the third comic. Halfway down the page I could see it wouldn't work. I needed a clear, easily readable sequence of panels on the bottom, and this layout wouldn't let me achieve that goal.

ADD MORE DETAIL

Once I was satisfied that the basic proportions of the drawing were correct, I penciled in more detail. I let some less important parts of my drawings (such as Lyra's earrings on the top panel) jut out of the live area, as shown by the dotted lines. The area outside the safe zone might get cropped out if the artwork is published in comic book format, so always be sure to keep important details inside.

This is the final pencil drawing of the third comic just before it was inked in. This page features my cast of characters and employs several standard manga expressions, including sparkly eyes, the eye gleam, and sweat drops (see pages 24–25 on expressions and Chapter 2: Drawing Eyes starting on page 26). Also note Space Weasel's sleeping expression in the second from the bottom, right panel. The snot bubble coming out of his nose and his drooling mouth are both commonly used in manga to depict sleeping characters. Note that instead of thought balloons or speech bubbles, I have Space Chicken and Space Weasel communicate with signs. It just seemed to fit this comic.

INK IN

The second and third comic pages are seen here after they were inked in, using a Copic Sketch Marker (100 Black) and a Pigma Micron pen (05 and 08). I handwrote some text but will put most of the final text in using the computer. Erase pencil lines as well as you can. Once the image is scanned into the computer, you can use Eraser or Brush tools (or adjust brightness/contrast) to take out lines, but it's easier if they're not there in the first place.

SCAN IN IMAGE AND COLOR IT IN

You need to have a scanner attached in order to transfer artwork to your computer. I have an HP ScanJet that scans an image no larger than about 8 ½ by 11 ½ inches. Larger scanners are nice, but they cost more money. If your artwork is larger than your scanner, you'll have to scan it in pieces and attach them together using Photoshop or a similar program. After scanning the finished ink page into Photoshop (Image Mode: Grayscale; Image size: 600 dpi—later converted to RGB color), I used Select: Color Range to highlight, copy, and paste the black lines into a new layer. I then colored the bottom layer using the Paint Bucket, Gradient, and Brush tools. At first I focused on blocking in the character's colors. Then I chose contrasting background colors (such as green and tan) that were not used much on the characters. I made sure the colors were muted (if they were high in saturation, the background would be too distracting, and the whole page would seem too busy). I wanted to make the entire page's colors balance each other and coordinate well. For instance, I might include a green background on a top panel and then make sure that the color "flowed down" the page by adding the same color in the background of various panels below.

Also, keep complementary colors in mind as you work. Complementary colors are those of opposite hue that, when placed next to one another, spring to life on a page. The three main complementary color pairs are blue and orange, red and green, and purple and yellow. I used variations of several complementary colors in my artwork throughout this book. Even if not quite exact, a close match can still produce a pleasing result (for instance, orange is close enough to red that, if paired with green, can really liven up a picture). I used the Text tool in Photoshop (using Comic Sans MS type) to key in text.

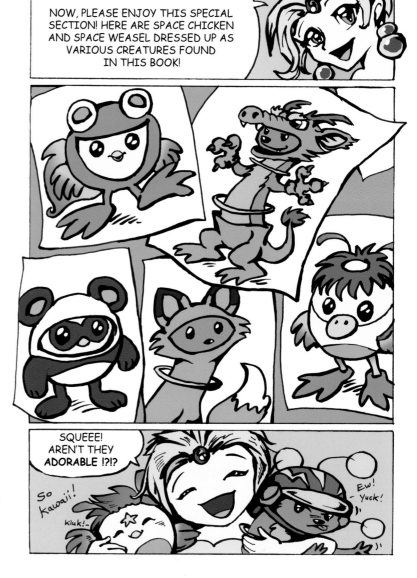

NOW, PLEASE ENJOY THIS SPECIAL SECTION! HERE ARE SPACE CHICKEN AND SPACE WEASEL DRESSED UP AS VARIOUS CREATURES FOUND IN THIS BOOK!

SQUEEE! AREN'T THEY ADORABLE !?!?

So kawaii!

kluk!-

Ew! - Yuck!

Ew!

FINAL TOUCHES

Once I felt the basic colors of the page looked good, I went back and worked on the details of each character, adding highlights and shadows. I used Brush tools and the Dodge/Burn tool for this effect (often using the Wand tool to select the areas I wanted to focus on). In addition, I varied the tone of some of the background panels when I felt they looked too flat. Adding a subtle, light-to-dark shading can add some interest to an otherwise dull panel. Just be careful not to overdo it—add too many variations and highlights or shadows, and the whole page begins to look too busy. Sometimes, I used the Wand tool to select two or more panels at once and then a Gradient tool to fill in a light-to-dark tone on both at the same time. This technique adds unity to the panels and thus, the whole page. Keep adding details until the page starts to look good—then let it alone for a while so you don't overwork it. Try flipping the image upside down to get a fresh look, as well. Work on it as needed. If you come back later and it still looks good, you're done!

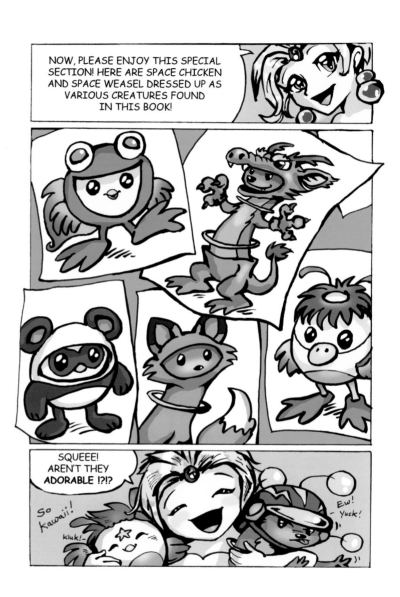

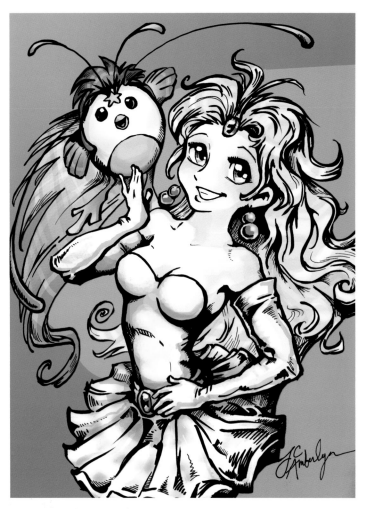

COMPOSITION

When working on your manga pages it's essential to think about overall composition. In this portrait of Lyra and Space Chicken, I used layers in Photoshop to work separately on the figures and the background. This allowed me to work with the background, experimenting with tones and colors, until I found what I liked without affecting the two figures in any way. I ended up using a Gradient tool to apply a graduated tone to the background instead of leaving it a solid color. It made the characters seem to "pop" out just a bit more.

Note the composition of this piece. The smaller figures of Space Weasel and Space Chicken circle around the large, central figure, creating a circular composition that leads the eye around and around the page. The relatively flat, simple coloring of the characters lends a cartoony feel to the piece. I used a few cartoon-like squiggly lines to add a sense of movement.

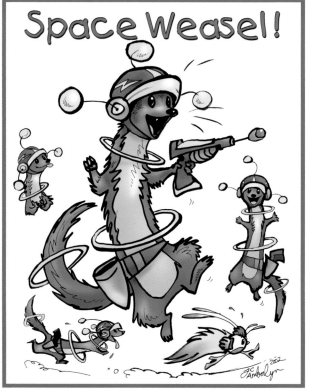

MAKING ART FLOW ON A PAGE

This page is from my Original English Language (OEL) manga series called *Spiral*, which was published by Radio Comix several years ago. Lydia, the main character, has just encountered a dragon for the first time. This is a good example of creating a visual path that leads the eye through a page.

On this page, I have used red to outline the path, or flow, of the action. Note how the direction of a head or neck dovetails with that path. I also used overlapping objects (like Lydia's scarf or the dragon's horns) to help lead the eye through the page. The page also features a figure eight composition. I used green lines to point out the parts of the drawing that contribute to a double-looping shape that resembles the number 8 and guides the eye around (and around) the page, creating visual harmony.

WORKING WITH TONE

IN THIS SECTION, we move from specific projects to more general topics that you, the reader, may find helpful while creating manga art and stories of your own. These topics include toning or shading a picture and the use of action lines to express energy or movement.

Japanese manga drawings often include tones to give the (usually) black-and-white artwork a greater sense of depth and mood. Traditionally, artists would glue "tone sheets" to their inked manga work, using craft knives and sand erasers to cut and rub away unwanted details and leave tone filling in the desired areas. Today, a new option includes toning in with the computer. Either way works, so the choice just depends on what the artist is most comfortable using. Because I am most familiar with computer techniques, the focus here is on creating pictures with Photoshop.

Add some excitement to your manga pages!

HALFTONE FILTER

This inked line drawing of a wolf could be toned in many different ways. One of the most frequently used techniques is the Halftone Filter in Photoshop, and even that can be approached several different ways. For example, use a line art drawing (Image Mode: Grayscale; and Image Size: 600 dpi).

1. Go to Layers, and Duplicate the Layer so that you have a new layer you can edit [**PC Shortcut: right-click on Background Layer and select Duplicate Layer; No Mac Shortcut**]. You can delete the original locked Background Layer if you like.

2. Now create a New Layer. (You should have "Background Copy" and "Layer 1" or "Background Copy 2" above it.) Set Layer 1 to "Multiply" instead of "Normal." Use the Paint Bucket tool [**PC & Mac Shortcut: G**] set at 75% opacity, and fill in Layer 1 with a medium gray. Because the layer is set to multiply, your black line art should not be affected, but everything else will now look slightly gray.

3. Now select Filter: Sketch: Halftone Pattern. In the dialogue box, make sure Halftone Pattern is chosen, and select Size, Contrast, and Pattern Type. (I used 2, 50, and Dot, respectively.) You will now have a tone pattern across the image that you can erase and modify as desired, leaving tone only where you want it. Use the Eraser tool [**PC & Mac Shortcut: E**] in Mode: Brush, and choose a brush that suits your needs (I used an airbrush for a soft edge). For a few areas, I used the Eraser tool at about 50% opacity to achieve a halftone.

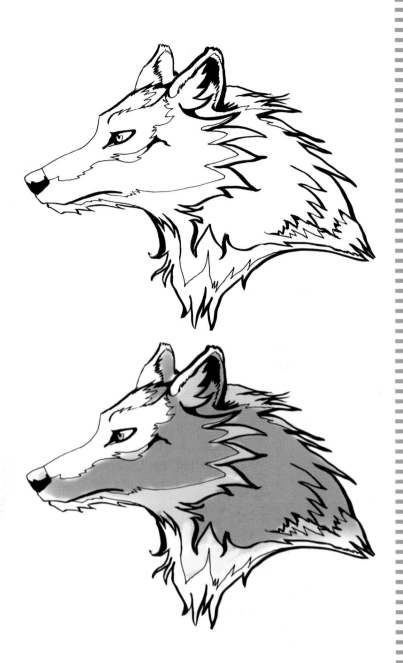

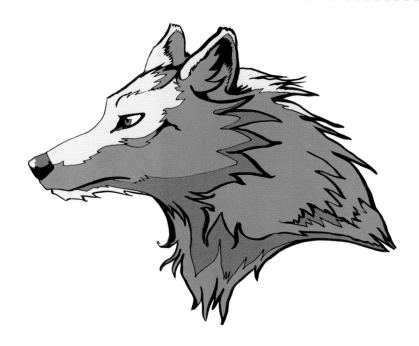

CREATE PREMADE BITMAP TONES

Another option is to create premade bitmap tones so that you can fill in broad areas with them later.

1. Create a new image (I set it at 600 dpi and 4 by 4 inches). Fill it in with a gray tone using the Paint Bucket tool. Select Filter: Sketch: Halftone Pattern (I selected Size: 1, Contrast: 49 and Dot Pattern). I then used Filter: Blur: Gaussian Blur (set at .7 pixels) to soften the effect a little.

2. To make a pattern I could use later, I selected Filter: Pattern Maker. In the dialogue box, I select the entire gray screen. Then I select the Smoothness and Sample Detail (higher numbers mean smoother renders—and longer render times, which means it will take longer to do). I selected 3 and 21, respectively. Hit "Generate." On the bottom right of the dialogue box, where the Tile History tile is shown, are several small icons pictured below it. On the left is an image of a computer disk, which is the Saves Preset Pattern button. Click on that, name your pattern, and select "OK." Cancel Pattern Maker.

3. Now, select the Paint Bucket tool, and on the top menu bar you'll see an image of the Paint Bucket, a box to select Foreground or Pattern (select the latter), and then the Pattern Picker box, which you should click on. A box will pop up with tiles of various patterns available. Your new pattern should be the latest one added. Select that, and now you can use the Paint Bucket tool (again, set to Pattern) to fill in the bitmap tone (or any other pattern you create) anywhere you want. I created another, somewhat darker shadow tone for the deeper shadows and then filled in the image using both the medium and shadow tones in order to add depth to the wolf's head and neck. Deciding the white areas needed some definition, I filled in those using the medium pattern with the Paint Bucket tool set at 25% opacity.

CREATE TEXTURE AND TONE

There are many ways to achieve a toned effect in Photoshop, so try experimenting on your own to create just the effect that you want. To create this snow scene, I used the previous drawing and created a new layer in Photoshop, setting it to "Multiply," and then followed these steps:

1. I went back to the original layer with the drawing on it, selected the Magic Wand tool set at 50% tolerance, and selected the blank space (negative space) around the wolf, not the wolf itself. Then, I went back to the new, blank layer and, with the selection still active, filled in a medium gray tone. This created a gray tone for the background, which can be edited without affecting the wolf.

2. To get the snowy background, I used Filter: Sketch: Halftone Pattern (Size: 1 and Contrast: 49), then Filter: Noise: Add Noise (set at Amount: 105), followed by another Filter: Sketch: Halftone Pattern (Size: 1 and Contrast: 49). Next, I selected Filter: Render: Clouds, then Filter: Sketch: Water Paper set at Fiber Length: 15, Brightness: 70, and Contrast: 70. I then selected the Eraser tool, using a Spatter brush set at about 400 pixels, followed by Brush: Airbrush Soft Round 65 for the snowflakes.

3. I then deselected the background area, selected the wolf drawing layer, and used the brush to paint a few snowflakes on my wolf. (You can occasionally use a smaller size so that the snowflakes have variation.)

COLOR A TONED IMAGE

You can also color a toned image if you like. Here, I used the previous image, opened the Layers window and converted the image from Grayscale to RGB color mode (Image: Mode: RGB Color). Then I followed these steps:

1. I clicked on the "eye" to the left of the bottom Background layer, hiding it so that the top layer (Layer 1, the one with the snowy background toned in) was the only one visible. Select top layer.

2. Using the Wand tool set at 50% Tolerance, I clicked in the empty, nontoned space where the wolf would be, selecting just the wolf shape. I went back to Layers and clicked the "eye" on the bottom wolf layer again so that I could see all the line art and tones.

3. Then I made sure the top "snowy background" layer was active in the Layers window. This layer was still set on Multiply, allowing me to color that layer without affecting the line art or tone of the layer below. Using an airbrush, I added color to brighten the image. The tone already added some depth to the image, so I concentrated more on color: blues in the shadows and the warmer brown-gray color where light falls on the form. I added a bit of orange to the eyes and blue to the nose.

4. At this point, I went to the Photoshop menu and chose Select: Inverse. This inverts the Magic Wand selection I had made earlier to now exclude the wolf and include only the background. I chose an ice-blue color and an Airbrush Soft Round set at about 35% opacity. Looking up at the brush menu, I selected Mode: Behind instead of Normal. This allowed me to color in the snowy scene without obliterating the snowflakes. I used the brush to add a blue cast to the snowy scene. I wanted to soften some jagged areas, so I then selected Mode: Dissolve (at low opacity) and used the brush to add some more subtle texture to those areas.

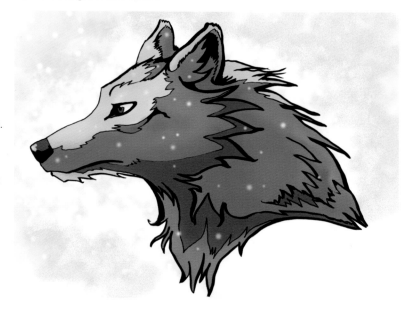

There are other ways to add texture and tone to an image. Try experimenting to find some of your own. Here is one more way you can add tone to a picture. First, I copied and pasted a new line-art layer above the original layer and then selected the bottom layer to tone in. I used the Paint Bucket tool to fill in areas of medium and dark gray.

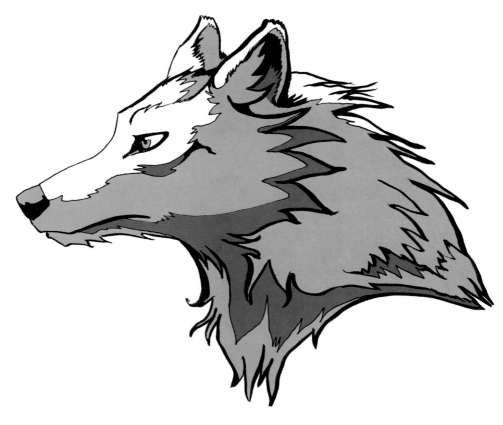

To continue, in Photoshop's menu, choose Select: Color Range, choose one of the grays (I selected it with Fuzziness: 0, using Selection, not Image). Hit "OK." Now choose Filter: Noise: Add Noise. Select 50% Uniform. This adds a grainy, toned effect to that shade of gray. Now do the same for the other gray shade. Finally, fill in very light gray on the areas of the wolf that are hit with sunlight, and use the Add Noise filter on those areas as well, choosing 15% Noise instead of 50%. Deselect the image. Use a solid brush to add a little white highlight to the wolf's nose and you're done.

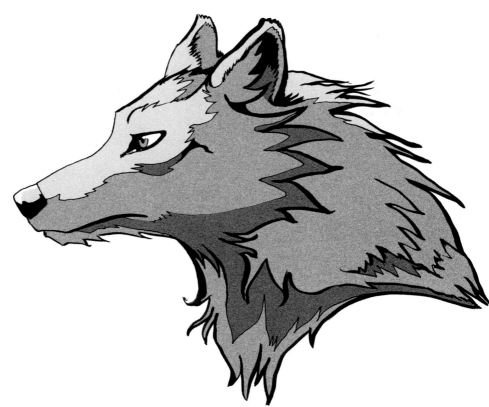

ADDING EXCITEMENT AND DRAMA WITH LINES

Many manga drawings are enhanced by lines that convey action or excitement. An artist can draw lines radiating around a figure to indicate excitement, or have lines flowing in the direction of a figure's movement to add a sense of motion. If your illustrations are hand-drawn, the lines can be added on paper, or they can be added digitally on the computer. The example below was hand drawn, then scanned into Photoshop for digital manipulation.

A pencil sketch of an excited, happy rabbit character.

The finished ink drawing on paper.

Lines can be added by hand, using a ruler to ensure straightness. A few extra short lines were added later (without a ruler), and a few were erased digitally on the computer to achieve the desire effect.

ADD LINES DIGITALLY

Lines can be added by hand or digitally. The lines below were added
digitally. First, I used Magic Wand tool (at 50% Tolerance) to select the
background and leave the rabbit untouched. I selected Line Tool [**PC &
Mac Shortcut: U**]. On the Line tool menu bar, I chose Fill Pixels and made
sure Line Tool was selected (as opposed to Pen Tool, Polygon Tool, or any
other option). I used weights of 5, 8, and 10 pixels to create the lines in this
drawing. Deselect the background, and the drawing of a rabbit with an
action-line backdrop is complete.

ADD COLOR

This image can be colored in if you wish. To do that, I used Select: Color Range (Fuzziness: 0; Selection, not Image) to copy the line art and paste it to a new layer. Work on the bottom layer, leaving the line art above undisturbed. I colored the rabbit using the Paint Bucket tool [**PC & Mac Shortcut: G**]. To work on the background, I again used Select: Color Range to select all the white in the image. I had also selected the whites in the eyes of the rabbit and used the Lasso tool (Feather: 0 Pixels) and the Alt key to subtract the whites of the eyes from the rest of my selection. With only the background selected, I used the Gradient tool [**PC & Mac Shortcut: G**] to fill it in. I chose yellow and green at 70% opacity.

INDEX